CAMILLE SILVY

River Scene, France

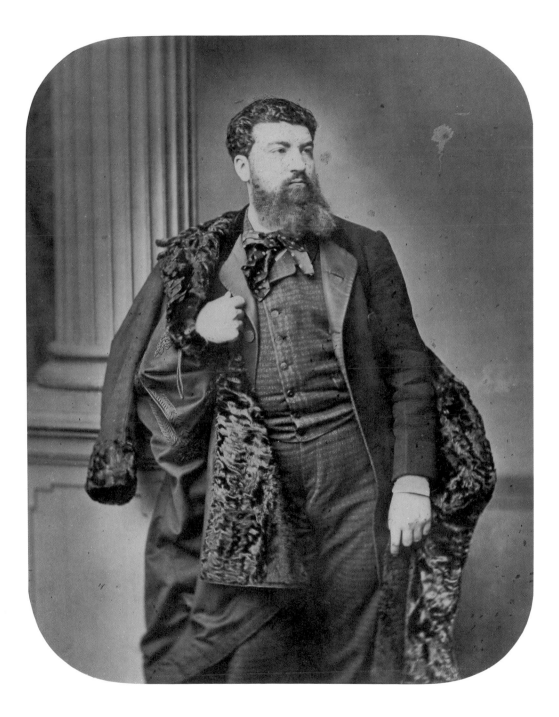

CAMILLE SILVY
River Scene, France

Mark Haworth-Booth

GETTY
MUSEUM
STUDIES
ON ART

MALIBU, CALIFORNIA 1992

© 1992 The J. Paul Getty Museum
17985 Pacific Coast Highway
Malibu, California 90265-5799

Mailing Address:
P.O. Box 2112
Santa Monica, California 90407-2112

Library of Congress
Cataloging-in-Publication Data

Haworth-Booth, Mark.
 Camille Silvy : River scene, France / Mark Haworth-Booth.
 p. cm.—(Getty Museum studies on art)
 Includes bibliographical references.
 ISBN 0-89236-205-7
 1. Silvy, Camille-Léon-Louis, 1834–1910. River scene, France.
2. Silvy, Camille-Léon-Louis, 1834–1910. 3. Photography—France—
History—19th century. 4. Landscape photography—France.
I. Title. II. Series.
TR71.H39 1992
779'.092—dc20 91-44136
 CIP

Cover, foldout p. 120: CAMILLE SILVY (French,
1834–1910). *River Scene, France/La Vallée de
l'Huisne*, 1858. Albumen print from wet collo-
dion-on-glass negatives, 25.7 × 35.6 cm
(10⅛ × 14 in.). Malibu, J. Paul Getty Museum
90.XM.63.

Frontispiece: ANTONY-SAMUEL ADAM-SALO-
MON (French, 1817–1881). *Camille Silvy*, exhib-
ited 1859. Albumen print from wet collodion-
on-glass negative, 23 × 18.3 cm (9¹/₁₆ × 7³/₁₆ in.).
Paris, Société Française de Photographie.

All photographs are reproduced courtesy of the
owners and institutions unless otherwise
indicated.

CONTENTS

(As if a river should carry all
the scenes that it had once reflected
shut in its waters, and not floating
on momentary surfaces).

❦

Elizabeth Bishop

FOREWORD

WESTON J. NAEF

CAMILLE SILVY, WHO LIVED AND WORKED in France and England in the 1850s and 1860s, is best known to the twentieth century through the single photograph that is the centerpiece of this book. Although the photograph was created in France, the first print to be sold went to a British collector, Chauncey Hare Townshend. Moreover, it was British connoisseurs and critics who first recognized the genius of this picture. To further complicate the story, the photograph's fame originated in Edinburgh, where the picture was first exhibited in December 1858.

Silvy's career in photography is full of irony. He was native to the land of the daguerreotype, which is the rarest type of photograph in that each one is a unique object. He moved to England, where photography as a process starting with a *negative* that can yield multiple prints was invented. He built his fortune by shrewdly exploiting the multiplicity inherent in the British negative-positive system. Silvy's artistic legacy, however, stems from the idea that photographs are unique. Apart from a handful of miniature copies, just four prints of *River Scene, France* survive, but none are identical. The two best prints—the example in the Victoria and Albert Museum, London, and the one in the Getty Museum—are so different in color and image structure that they could have been made from different negatives. The two other surviving prints, in the Société Française de Photographie, Paris, and in Nogent-le-Rotrou, are in less good condition. Together, the four prints represent an enigma within an enigma.

Silvy's life and art are a reminder that photography is a means of expression which swings like a pendulum between the two poles of multiplicity and singularity. *River Scene, France* is a highly finished composition that incorporates some of the most advanced visual ideas of the times and that had the potential to appeal to a large audience. Why have so very few exhibition-quality prints survived of a composition of such high artistic quality by an artist who had access to wide distribution and the incentive to exploit it? This is one of the questions Mark Haworth-Booth illuminates with great narrative skill and erudition in the following pages.

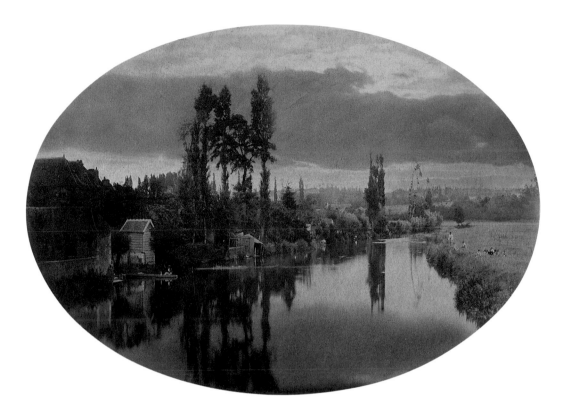

Debut: Edinburgh and London

"THE EXHIBITION OF THE PHOTOGRAPHIC SOCIETY opens this week," the art column of the *Edinburgh News* announced on Saturday, December 11, 1858, "and if the collection be neither large nor important, it has not been the fault of the promoters. It is said that a special messenger has been scouring London for specimens."[1] Silver medals were offered to competitors to honor achievement and encourage participation.

This was the Photographic Society of Scotland's third annual exhibition. The first, in 1856, had drawn from an anonymous critic a description of photographs as "pictures which, if they could be placed within a covered space and viewed with the aid of a large magnifying glass on a large scale, would almost impress on the mind the feeling of the real scenes among which we had wandered."[2] Photography, the last word in illusionism, was triumphing in the age of naturalism. The prestige of the medium rose in each successive year of the 1850s. The 1858–59 exhibition in Edinburgh was held, for the first time, in an elegant, purpose-built art gallery: D. R. Hay's Art Saloon, at 90 George Street, "one of the most centrical and easy of access in town."[3] The society's patron was Prince Albert and its president the internationally renowned scientist Sir David Brewster. The members were drawn from the wide variety of enthusiasts who had embraced the new medium in this decade of sudden and spectacular social success for photography.

"Every third man you meet may safely be set down as a photographic amateur," claimed the *Daily Scotsman*.[4] The *Photographic Journal* observed: "Even in the cold, frigid north of Scotland, this fascinating science has its devotees. . . . Every village and ham-

Figure 1. CAMILLE SILVY. *River Scene, France/La Vallée de l'Huisne*, 1858. Albumen print from wet collodion-on-glass negatives, 25.7 × 35.6 cm (10⅛ × 14 in.). Malibu, J. Paul Getty Museum 90.XM.63.

let . . . seems to be inoculated with a desire to promote the fine arts, by exercising their talent in producing pictures through the mysterious actinic power of light, so lately developed out of the darkness of bygone centuries."[5] In 1857 the essayist Lady Eastlake had asked:

> When before did any motive short of the stimulus of chance or the greed of gain unite in one uncertain and laborious quest the nobleman, the tradesman, the prince of blood royal, the innkeeper, the artist, the manservant, the general officer, the private soldier, the hard-worked member of every learned profession, the gentleman of leisure, the Cambridge wrangler, the man who bears some of the weightiest responsibilities of this country on his shoulders, and, though last, not least the fair woman whom nothing but her own choice obliges to be more than the fine lady?[6]

The new institutions formed to propagate theory, communicate technical knowledge, share practical experience, and organize international photographic exhibitions were founded by established social leaders, but they were thought of as possessing a broad, even democratic, social complexion. This was part of their novelty and attraction. Apart from the new professional photographers, the membership included others—publishers, stationers, and printers—who had a direct financial interest in the promotion of the medium.

A formal private opening, or *conversazione*, took place on the eve of the opening day in 1858. Newspapers reported the company present, headed by the lord provost of the city and representatives of the government, the university, the Royal Scottish Academy, and the professions, notably architecture and the bar. W. H. Fox Talbot, inventor of the calotype process, was there with his wife and daughter.[7] Many members of the first generation of photographic inventors and artists were still working and exhibiting. Visitors to the exhibition were able to measure the progress of photography from its beginnings less than twenty years before. Lady Eastlake had been thirty when the invention of photography had burst upon the world. Her essay on photography published in the *Quarterly Review* in April 1857 was probably still being discussed in December 1858. It is still often quoted today: "[P]hotography has become a household word and a household want; is used alike by art and science, by love, business, and

justice; is found in the most sumptuous saloon, and in the dingiest attic—in the sol-
itude of the Highland cottage, and in the glare of the London gin-palace—in the
pocket of the detective, in the cell of the convict, in the folio of the painter and ar-
chitect, among the papers and patterns of the millowner and manufacturer, and on the
cold brave breast on the battlefield."

Lady Eastlake was well informed about photographic technique and its prob-
lems. She was also immersed in the fine arts. Her husband, Sir Charles Eastlake, was
director of the National Gallery, London. She earnestly tested claims that photography
was already or would become a medium of the fine arts—and she found photography
wanting. It excelled at details but could not create unified, consistent forms. It suf-
fered, she argued, from insurmountable technical difficulties. She referred to the ex-
treme responsiveness of the negative plates of the day to violet and blue but not to red
and yellow, "the deepest blue being altered from a dark mass into a light one, and the
most golden-yellow from a light body into a dark."[8] The materials also gave a haphazard
account of nature's chiaroscuro. She conceded that there had been great improvements,
however. Thanks to the invention of the collodion negative in 1851, "the little bit of
landscape effect, all blurred and uncertain in forms, and those lost in a confused and
discoloured ground, which was nothing and might be anything, is superceded by large
pictures with minute foregrounds, regular planes of distance." She was thrilled by the
speed of collodion, which made new subjects possible, "last, and finest, and most in-
teresting of all, the sky with its shifting clouds, and the sea with its heaving waves."[9]
And yet, she found, the medium still could not be relied upon to describe the world
pictorially without either an embarrassing stutter or a bare-faced lie. It was a special
problem to bring together a detailed sky and ground, for example: "The impatience
of light to meet light is . . . so great that the moment taken to trace the forms of the
sky (it can never be traced in its cloudless gradation of tint) is too short for the land-
scape, and the moment more required for the landscape too long for the sky. If the sky
be given, therefore, the landscape remains black and underdone; if the landscape be
rendered, the impatient action of the light has burnt out all cloud-form in one blaze
of white."[10]

Lady Eastlake nonetheless remained an eloquent champion of the new me-

dium, because photography was "made for the present age, in which the desire for art resides in a small minority, but the craving, or rather necessity, for cheap, prompt, and correct facts in the public at large."[11] The *truth* of photographic details bestowed on them both fascination and depth. Photographs might miss, for example, the child's expression, but "minor things—the very shoes of the one, the inseparable toy of the other—are given with a strength of identity which art does not even seek."[12]

The first reports of the 1858–59 exhibition published in the Edinburgh press, which took an eager—not to say chauvinistic—interest in the occasion, drew delighted attention to the "commodious and beautiful hall," which was "in every respect, both as regards space, lighting, and decoration, all that could be desired for the purpose."[13] The gallery had been designed by one of the most distinguished interior decorators of the day. David Ramsay Hay[14] was a prominent innovator—and not only in Scotland. His was the scheme with which the Society of Arts in London was refurbished in 1845; the first photographic exhibition in Britain had opened there in December 1852. 90 George Street, at the height of its fame, contained a wealth of modern Scottish paintings and a Turner of Loch Lomond hung in a top-lit gallery probably designed, and certainly detailed, by Hay himself. The paintings went in 1847, but the gallery must still have been an elegant and impressive space in 1858. Now owned by Laura Ashley Ltd, it survives with traces of red and gold on the walls: "Through practical experiment in his own and his clients' picture galleries, Hay had proved that a particular shade of 'purple' sometimes described as a 'claret' colour was the best medium for surrounding works of art."[15]

Between one thousand and twelve hundred photographs were displayed, together with photographic jewelry and stereoscopes of various designs. At the head of the saloon, which was divided by two screens, were large pictures, most notably Tommaso Cuccioni's *Tiber* (1858?), composed of three seamlessly joined mammoth-plate prints. Above were monumental views of Egypt by Francis Frith. The London firm of Caldesi and Montecchi had recently photographed Raphael's cartoons at Hampton Court Palace, and two of their immense albumen prints were also prominent. Size was one of the surprises of the exhibition: photographs now seriously rivaled the scale, as well as the accuracy, of even the grandest engravings.

12

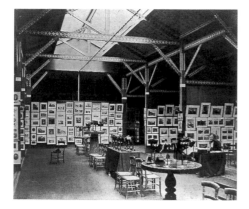

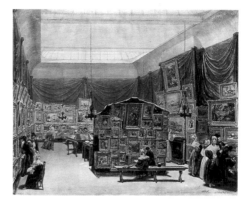

Figure 2. CHARLES THURSTON THOMPSON (British, 1816–1868). *The Photographic Exhibition, South Kensington Museum*, 1858. Albumen print from wet collodion-on-glass negative, 29.1 × 33.5 cm (11 × 13³⁄₁₆ in.). London, Victoria and Albert Museum.

Figure 3. SIR GEORGE SCHARF (British, 1788–1870). *Interior of the Gallery of the New Society of Painters in Watercolours, Old Bond Street*, 1834. Watercolor, 29.6 × 36.9 cm (11¹³⁄₁₆ × 14½ in.). London, Victoria and Albert Museum.

The display was well lit, elegant, and didactic: "Portraits and landscapes by all the leading contributors are so mixed up and harmonized, that the visitor can institute comparison not only between the different artists, but the different processes, throughout the room."[16] The "harmonization" and the mingling of works by different contributors may have resembled the hanging style employed by the Photographic Society of London in its exhibition held at the South Kensington Museum in January 1858, which was highly regarded by critics.[17] "Unity of design" was uppermost.[18] As is the case with nearly all of the early photographic exhibitions, no visual record of the installation at Hay's gallery appears to survive. However, the general hanging scheme probably resembled that seen in Charles Thurston Thompson's photograph of the show at the South Kensington Museum (fig. 2), which in turn followed the practice of exhibitions of watercolors (fig. 3).

Scottish photographers did not hold back. Horatio Ross, vice president of the society and a sportsman of preternatural gifts who had once shot butterflies out of the air to entertain Count Esterhazy in an Edinburgh garden, showed no less than fifty,

mostly sporting, scenes. The Continental master Gustave Le Gray was represented by three prints. Some exhibits were lent by private collectors and many by dealers in fine photography. Oscar Rejlander, stung by the rejection of his notorious composite photograph *The Two Ways of Life* (1857) the previous year, was not disposed to submit photographs, but the organizers arranged for some of his prints to be bought and placed these in the exhibition.[19] Several commentators chose Rejlander's large view of Loch Katrine—redolent of Sir Walter Scott's *Lady in the Lake* (1810)—printed from several negatives, as the most magnificent landscape in the exhibition.[20] Selling was part of the point of such shows. Sales of prints from the society's first exhibition had been described as "very considerable . . . demand is such that it will take a considerable time to furnish the requisite supply."[21] Did this mean twenty prints sold or two hundred? Many—most—of the photographs mentioned in reviews must now be presumed lost. Even by 1858, Rejlander's composition existed in only two prints.[22]

Reviewers of the exhibition—and there were many—were particularly interested in methods of permanent printing, such as John Pouncy's carbon process and the photoglyphic prints by Talbot (nine were added to the show on January 10; this was the first time Talbot had exhibited his attempt to unify the processes of photography and printing in ink).[23] They were also interested in instantaneity—particularly discussed was a snapshot of an express steamer on the Clyde, taken by a Glasgow amateur, John Kibble (it was exposed in no more than a fortieth of a second but developed for no fewer than ninety hours[24]—and the composite prints of Rejlander and Henry Peach Robinson, who excelled at combining several different negatives into one seamlessly printed photographic image. Writers were more persuaded of the fine art qualities of pure photography. They discussed landscape the most, recognizing real improvements in the rendering of aerial perspective and a new delicacy in the treatment of details. Credit was given to the makers of the lenses brought forth by the collodion era and the new popularity of photography in the 1850s:

> The beauty and distinctness of photographic drawing depend primarily upon the perfection of the medium through which an image is cast upon the sensitive material. A great competition has accordingly arisen in the construction of lenses, and both abroad and at home science and natural philosophy are brought into the field in the preparation

of perfectly faultless glass, and the mathematical arrangement of its focal power. The result has been that in the productions of Petzval, Voigtlander, and Ross, we have lenses hitherto unequalled; and yet higher degrees of perfection will doubtless be attained.[25]

Many critics saluted Camille Silvy (frontispiece), a new master of the photographic draughtsmanship made possible by the new lenses, and a print of his *River Scene, France* (cover, fig. 1, foldout p. 120). The first review of the exhibition, carried by the *Daily Scotsman* on December 18, the opening day, contains this passage:

> In the landscape department the present Exhibition seems peculiarly rich, and we observe a marked improvement in the choice of subjects and the mode of treatment. Hitherto the landscape studies were generally deficient in gradation of tint indicative of distance, and in rendering those sunny effects which exist in nature, and for which the landscapes of Turner, Claude, &c., are so distinguished, but really some of the landscape photographs in the present Exhibition are perfect pictures in their style, combining the most exquisite detail with the fine aerial perspective so much desiderated. If colour could only be attained, the sun would prove more than a match for our best landscape painters, but in many of the studies the want of that requisite is less felt from the absolute truth and perfection of the realisation in other respects. Let any one who may suppose we speak too favourably look at the wonderful view of a French river, by C. Silvy—No. 582. If this photograph is untouched, and taken from nature, it is a triumph of the art, and equal to any picture by Vander Neer [the Dutch seventeenth-century landscape painter Aert van der Neer] or other famous delineators of similar scenery.

The name of van der Neer, well known for river scenes, was not chosen by the critic at random. He may well have been thinking of *Landscape at Sunset*, then hanging in Paris in the galleries of the Louvre (fig. 4).[26]

Three days later, on December 21, the critic for the *Edinburgh Evening Courant* wrote:

> A great number of the sun pictures in this exhibition please in the highest degree by the beauty of landscape, the aerial distances, the disposition of light and shade, altogether irrespective of their being creations of the camera, careless touches of the sun, thrown off in a second or two. . . . 582. River Scene, France—C. Silvy. We cannot pass this picture of a new artist without notice. The water, the foliage, the figures, the distance,

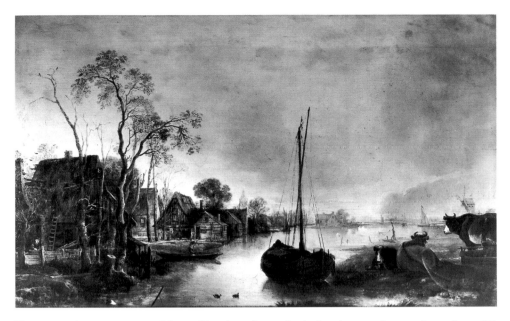

Figure 4. AERT VAN DER NEER (Dutch, 1603–1677). *Landscape at Sunset*, circa 1640. Oil on panel, 48×80 cm (18⅞×31½ in.). Paris, Musée du Louvre.

the sky, are all perfect. But above all, what some perfect photographs want, they are all beautiful. It is the most exquisite landscape we have seen in photography.

The new year also started well for Silvy. The *Daily Express* wrote on January 1, 1859:

A proof of the growing importance of this Society is found in the fact that some of the leading photographers in London and Paris, either directly or through their agents, send some of their finest work to its Exhibitions. . . . "A River Scene in France" (No. 582), by a French artist, M. Silvy, whose name is not yet very generally known in this country, is one of the most beautiful pictures in the whole collection, and one of the finest land-scapes that we ever remember to have seen reproduced by photography.

The *Witness* for January 5 noted that "No. 582, by Le [sic] Silvy, 'River Scene in France', is particularly fine."

A chance visitor to the exhibition was moved to send a long, two-part review

to the Liverpool *Photographic Journal*. Signing himself "Sel d'Or" (the name of a much-used gold-chloride toning solution), this commentator produced an interpretion of Silvy's photograph: "a singular picture with a dark thunder cloud ready to burst, black as midnight, yet clear and transparent in the shadows. Is this a true portrait of that country? Is it a method of speaking out, yet escaping the fate of a political martyr? To these questions I cannot reply, as I do not profess to be able to solve such enigmas; but as a picture it has my approbation."[27] If Sel d'Or regarded France as being under a cloud because of Louis Napoleon's brutal coup d'état carried out on the nights and days of a December six years previously, he may have chosen this particular image not as a cliché but specifically because of its use in Victor Hugo's *Napoléon le petit*, published in 1852. The exiled poet's magnificently scornful volume, with its sharp eyewitness report on the coup, sold a million copies around the world, including seventy thousand in translation in England.[28] The same imagery of light and shadow, sun and clouds, patriotism and Louis Napoleon-ism, informs Hugo's volume of poems *Les Châtiments* (1853)—which, André Maurois wrote, "led the imagination from past glories, through present shame, to the immensities of hope."[29] The treason and murder of December 1852 had not, of course, been forgotten by 1859.

A final review of the exhibition, published by the regular—but anonymous[30]—critic of the London *Photographic Journal* on February 5, was also the most generous. It may have been the most gratifying to Silvy, as the journal was readily available in Parisian photographic circles:

Perhaps the gem of the whole Exhibition is (582) "River Scene—France", by C. Silvy. We have seen no photograph which has taken our fancy so much as that exhibited under this unpretending title, by Messrs. Murray and Heath. The natural beauty of the scene itself, rich in exquisite and varied detail, with broad soft shadows stealing over the whole, produce[s] a picture which for calm, inviting beauty we have not seen equalled. The works of M. Silvy have not hitherto been seen here, but we hope hereafter that we shall have many such in our Exhibitions.

We cannot know whether, or how many, Silvy photographs were bought as a result of all this publicity. None have ever come to light in Scotland. However, apart

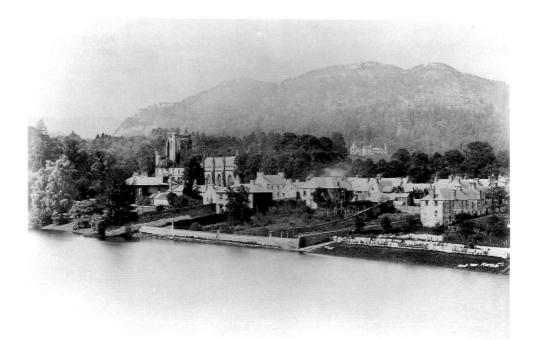

Figure 5. THOMAS ANNAN (Scottish, 1829–1887). *Dunkeld*, circa 1860. Albumen print from wet collodion-on-glass negative, approx. 26×34 cm (10¼×13⅜ in.). By courtesy of Sotheby's, London.

from the enthusiasm of the critics, there is perhaps one other piece of evidence of Silvy's early success there. The general photographic qualities of *River Scene, France* inform several landscapes made relatively early in his distinguished career—around 1860—by Thomas Annan (fig. 5). Who can say whether Annan's intricate but expansive riverside scenes derived only from the new equipment he had bought at this time,[31] or whether he bought the new camera and lens because of what he saw in the exhibition at which Silvy made his debut?

The organizers of the Edinburgh exhibition who scoured London for important new photographs must have visited Murray and Heath at 43 Piccadilly. Their shop, just east of the Royal Academy, was an obvious channel for a Paris photographer who wanted to exhibit and sell prints in Britain. *River Scene, France*, presumably taken

in the summer of 1858, could have arrived in London at any time up to the opening of the Edinburgh show—to which Murray and Heath also lent works by Bisson *frères* and Le Gray. The firm, set up in 1855 by Vernon Heath, photographer and nephew of the major collector of modern British art, Sir Robert Vernon, and Robert Murray, was the most pukka photographic outfit of the day.[32] Murray, one of the era's most respected makers of scientific instruments, was on friendly terms with scientists of his own generation such as Talbot, Alfred Smee, Sir F. W. Abel, and Robert Hunt.[33] The firm's prospectus states that "It is . . . intended to found a DEPARTMENT for the SALE OF PHOTOGRAPHIC PICTURES, selections being made from the best and most interesting specimens."[34] Britain's leading art magazine of the period, the *Art-Journal*, carried an enthusiastic article about the company in January 1859, lavishly praising the whole operation, including the print sales section.[35]

It is not hard to imagine that one of the most fastidious and original of contemporary collectors, the Reverend Chauncy Hare Townshend (1798–1868), would have found Murray and Heath's shop both convenient—Townshend lived at this time in Park Lane—and congenial. Although he subscribed to the *Art-Journal*,[36] it was really only necessary for Townshend—the original owner of the print of *River Scene, France* now in the Victoria and Albert Museum, London (fig. 6)—to walk along Piccadilly and look in their window to find out what the new firm had to offer. (Indeed, a critic complained that the exhibition of the Photographic Society of London which opened in January 1859 seemed stale because there were so many pictures in it "which everyone has seen, who, during the last six months, has walked along the Strand, the Haymarket, Regent Street, or Piccadilly."[37]) It seems likely that, although he traveled in Continental Europe frequently, Townshend assembled his splendid selection of prints by Le Gray—among the finest to have survived—at Murray and Heath and perhaps at other London dealers such as Henry Hering.[38] Townshend also owned two complex landscapes (one with clouds) by André Giroux from about 1855. Giroux, a painter, made photographs like one, working uninhibitedly on the surfaces of both paper and glass negatives, scratching away at the emulsion, drawing and painting with india ink and other materials, adding clouds, highlights, reflections, even—at least once—a white, shocked-looking, foreground flower.[39]

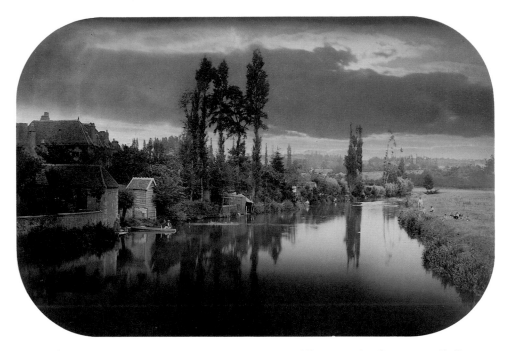

Figure 6. CAMILLE SILVY. *River Scene, France*, 1858. Albumen print from wet collodion-on-glass negatives, 24.5 × 36.6 cm (9⅝ × 14⁷⁄₁₆ in.). London, Victoria and Albert Museum.

Probably about the time he bought the Barbizon-style Giroux photographs, Townshend acquired a cognate Barbizon oil painting of clouds, grassland, and standing water, *Landscape in Les Landes* (1855; London, Victoria and Albert Museum) by Théodore Rousseau. Townshend collected across the contested frontier between paintings and photographs. As Victorians did, he collected other natural facsimiles such as fossils, and he was above all a collector of gems—which have an interesting structural relationship with photographs as intricate natural items that are also clearly artifacts. He was a savant of wide and illustrious acquaintance, sufficiently close to Charles Dickens to receive the dedication of *Great Expectations* (1860–61) and to Wilkie Collins to be awarded a more questionable accolade: Townshend was the model for Mr. Fairlie, the appalling connoisseur in *The Woman in White* (1860). Although known as a poet and notorious as a mesmerist, Townshend's most important creation was his collection.

His house possessed the character of an elegantly and attractively appointed private museum. He kept his print by Camille Silvy in a portfolio in a press among his other fine photographs, prints, and drawings, which he bequeathed—with his collection of paintings, jewels, and other precious objects—to the South Kensington Museum (ancestor of the Victoria and Albert Museum) in 1868.

Other members of the elite to which Townshend and Dickens belonged were touched by photography. The sometime Pre-Raphaelite Charles Allston Collins, Dickens's son-in-law and Townshend's friend, painted *May, in the Regent's Park* in 1851 (fig. 7). The view was probably taken from a window in Collins's family home at 17 Hanover Terrace. Malcolm Warner has written of this picture: "As a distinctively modern, urban landscape it is a kind of setting much used in the novels of the artist's brother, Wilkie Collins. When first exhibited, it was adversely criticised for its emphasis on minutiae and seeming lack of composition"—in other words, for its photographic effect.[40]

Another Pre-Raphaelite, also tired of generalizations, was in trouble—and his work is closer still to the iconography of leisure on the urban outskirts which, as we shall see, is the subject of Silvy's photograph. Ford Madox Brown began painting *An English Autumn Afternoon*, a view from his lodgings in Hampstead, north London, in October 1852, continued the canvas the following autumn, and completed the work early in 1854 (fig. 8). According to the artist, the critic John Ruskin commented unfavorably on the picture when it was exhibited in 1855, asking why Brown had chosen such an ugly subject. "Because it lay out of a back window," was Brown's reply. He described his painting as "a literal transcript."[41] The deliberation of the painting of the landscape from foreground to far distance, all of which seems to be in focus, the touches of crude verisimilitude like (at center left) the patch of whitewashed garden against which a spade or fork is leaning, the young man and woman, the positioning of subsidiary figures (like the man on the ladder picking fruit), the feeling of height— perhaps even the time of day ("The time is 3 p.m.," observed the painter)—all these qualities suggest that Brown's picture might be thought of as a companion to Silvy's photograph (which might as well have been titled *A French Summer Afternoon*). Brown's painting partook of photography; Silvy's photograph, as we shall see, partook of painting. Both projected the new subject of leisure, at the spot where the town looks into

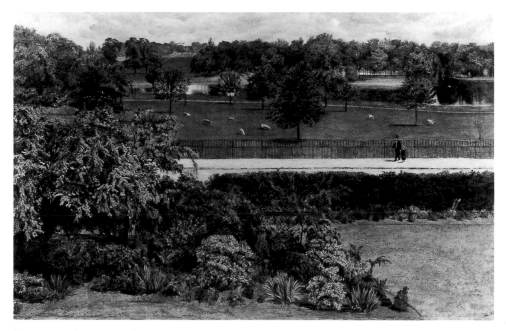

Figure 7. CHARLES ALLSTON COLLINS (British, 1828–1873). *May, in the Regent's Park*, 1851. Oil on panel, 44.5 × 69.4 cm (17½ × 27⁵⁄₁₆ in.). London, Tate Gallery.

the country, and weather exerts its precise effects upon sensation, and the eyes give themselves up to the enjoyment of everything that can be seen from a good vantage point above an expansive, abundantly detailed prospect on a sunny afternoon.

The paintings by Collins and Brown could be called camera works because both depict visual phenomena from the fixed position of a room. At the end of the decade, Charles Baudelaire was to condemn pictures that merely recorded what could be seen through the square of a window—trees, sky, houses. He condemned naturalism for its lack of interest in composition.[42] Certainly, photography became fascinating to painting. Reviewing a contemporary exhibition at the British Institution in 1854, the *Art-Journal* wrote that the subjects of the rising school of artists could be classified as "small genre subjects, and all but photographic imitations of landscape nature."[43] However, the paintings by Collins and Brown suggest an appetite for new social, psy-

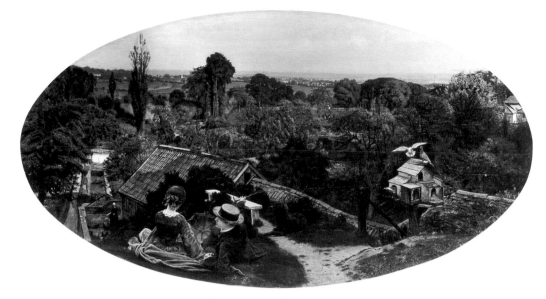

Figure 8. FORD MADOX BROWN (British, 1821–1893). *An English Autumn Afternoon*, 1852–84. Oil on canvas, 72 × 134.6 cm (28¼ × 53 in.) (oval). Birmingham, Museum and Art Gallery.

chological, and visual experiences which it is absurd to dismiss either as clumsiness or as naïveté.

For reasons that will become clear later on in the present narrative, it seems likely that Townshend bought his *River Scene, France* print not long after it reached England, in the autumn or winter of 1858 or early 1859. Maybe he bought it on a visit to Murray and Heath, but maybe he saw it in the exhibition at Edinburgh. Or he may have seen it in an exhibition organized by the Photographic Society of London that opened in January 1859 and to which Murray and Heath lent a *Landscape* by Silvy. The society opened this, its sixth annual exhibition at the Suffolk Street Gallery, otherwise known as the Gallery of the Society of British Artists, off Pall Mall. As usual, the quantity of exhibits was astonishing—"643 frames but twice as many separate photographs"[44]—but there were three rooms en suite that were large enough to show all the works without any central screens.[45] For the first time, prices were given in the catalogue. This was presumably because, by this date, nine-tenths of the exhibitors

were professional photographers.[46] Silvy's *Landscape* (number 573) was priced at twenty-five shillings, a little more than twice the cost of Roger Fenton's larger landscapes and more expensive than both Frith's famous mammoth plates of Egypt (fifteen shillings) and Robinson's notorious *Fading Away* (also fifteen shillings). The price of the Silvy suggests a photograph of large size or one requiring considerable manipulation. It is difficult to feel certain that *Landscape* was *River Scene, France*. In any event, *Landscape* did not meet with acclaim, nor have I found any reference to it that identifies the subject with certainty as the same as the photograph shown earlier in Edinburgh. There is an almost complete silence, in fact, concerning this picture.[47]

There is a possible explanation. There were thought to be too many photographic exhibitions in 1858–59, and in the autumn of 1858 the Photographic Society of London decided to ban from its next exhibition any photographs that had already been publicly displayed. This did not apply to the Edinburgh exhibition, and after a while the whole idea was rescinded anyway—but arrangements for the 1859 show were already in disarray. The following account of that exhibition in the *Athenaeum* suggests that *River Scene, France* must have been present, although neither Silvy nor his photograph are named:

> Water and cloud with all their fugitive beauties are still as unfixed as ever, and promise for some time at least to be to the hooded men what quicksilver was to the alchemysts, the unchainable and truant spirit that tempted them by apparently listening to their spells and yet refusing to own their power. This year, it is true, the photographs in these rooms almost entirely English, are sharp as if drawn with a knife-point, and yet full of dark cavernous depths and brooding filmy shadows: still it is in their size and breadth that their originality consists.[48]

The *Observer* for January 9, 1859, considered the difficulties of landscape carefully—pointing out, for example, the problems with rendering green, particularly in foreground foliage, the problem of the minute highlights on leaves "and the hard outlines of the foliage against the sky, the delicate gradations of which cannot be realised without sacrificing the foreground." Perhaps it is significant that the paper added: "It is a matter of disappointment that some of the more recent triumphs in the art are not

illustrated in the present collection."

The one specific reference to Silvy's *Landscape* in the press unfortunately does not indicate conclusively that *River Scene, France* was shown:

> There is a very charming landscape by Silvy (No. 573), that we should very much like to gain some more information about: the effect is very fine, yet not altogether satisfactory—the sky, evidently a natural one, being far too dark for the rest of the subject. We cannot quite make out whether it has been printed from a different negative to the rest of the picture, or from the same: there appear reasons for arriving at either conclusion.[49]

We shall return to this problem later.

The sixth annual exhibition was the most successful to date, critically and financially, for the Photographic Society of London. The medium had achieved its apogee. The *Times* for January 10, 1859, was more enthusiastic, if less judicious, than Lady Eastlake about the merit of photography as a fine art medium. Like many other critics in 1858–59, the reviewer found that photographers had drawn very close to painters, for "the photographer must have some of the best parts of a painter's knowledge. He must be a master of the laws of perspective, light and shade, and colour and composition, no less than those of photographic chemistry. In nothing is this exhibition more instructive than in the light it throws on the mutual relations of art—commonly so called—and photography, and in the proof it affords that the domain of the two are at many points hard to distinguish." This engaging belief was acted upon most dramatically in Paris a few months later, when a "Salon" of photographs was shown alongside the Salon des Beaux-Arts for the first time.

Paris

DESPITE THE EMINENCE OF LONDON, Paris was the more mercurial capital in the years of photography's youth. While Talbot's ultimately ascendant positive/negative process languished commercially in Britain in the 1840s, the French daguerreotype bred an international industry. In the 1850s, French photographers took up Talbot's invention, mainly using the waxed paper negative variant published by Le Gray in 1851. Again, while the English sculptor Frederick Scott Archer invented the wet collodion glass negative, the essential process—usually in combination with albumen printing paper—of the 1850s, '60s, and '70s, it was the French who thought up its most striking commercial application. This was the *carte de visite* (visiting card-size) portrait patented by A.-A.-E. Disderi in 1854, popularized by him with enormous success in Paris in 1858–59, and subsequently exploited by hundreds of studios all over Europe. Through such inventions, photography perfectly illustrated the astonishing European economic boom of the 1850s and the rapid industrialization of France under the Second Empire.

Paris was the first capital to organize a photographic society—the Société Héliographique of 1851—soon followed by the Société Française de Photographie (hereafter S.F.P.), founded in 1854. Part learned society, part lobby, part club, the S.F.P. served an international membership in Saint Petersburg, Madrid, Rome, Barcelona, Havana, Tiflis, Lima, London, and elsewhere. Permanent staff was employed to produce the society's important *Bulletin* and—from 1855—its biennial exhibitions. The society subscribed to an impressive range of journals covering chemistry, history, industry, and the fine arts, as well as photographic journals from England and America, and was the model for later societies formed in London, Edinburgh, and elsewhere.

French photography triumphed at the Exposition Universelle held in Paris in 1855. For Nadar, the great photographer, humorous draughtsman, friend of Daumier, early host to the Impressionists (whose first exhibition was held in his studio), and, when he wrote *Quand j'étais photographe* (1900), infectiously delighted reminiscer—for

Nadar, 1855 was magnificent because of this first large exhibition of photography in France. The international display in the Palais de l'Industrie set a new standard of elegance in its arrangements and had the thrill of novelty. Almost half a century later, Nadar recalled with rapture the expressions of the mime Debureau *fils* photographed by Adrien Tournachon. He remembered Carjat's grand (thirty-by-forty-centimeter) head of Frederick Lemaître and the impeccable collodion positives by Jean-Victor Warnod. These were works by men trained in the visual arts, he remarked, men who had been educated to see.[50]

And yet, Nadar wrote, negatives at that time were unretouched, positives too—apart from the most minor interventions. Retouching, he claimed, "so excellent and detestable and certainly indispensable in many cases," had first been conceived by a Munich portrait photographer. At the end of one of the galleries, Franz Hanfstaengl suspended, so that it could be seen clearly, a negative that had been retouched. Beside it he showed prints taken before and after the retouching. "This negative opened a new era in photography," wrote Nadar, who was simplifying the evolution of retouching negatives, which had been practiced widely prior to 1855.[51] Presumably, Hanfstaengl's display did cause a stir; indeed there was a controversy in the *Bulletin de la Société Française de Photographie*.[52]

One Parisian was already exhibiting portraits—of notables from the worlds of politics, finance, and high life—which revealed Hanfstaengl's methods. Antony-Samuel Adam-Salomon, a sculptor and photographer, had had the *nous*—so Nadar later wrote of his rival—to travel to Munich to learn the technique. This certainly gave Adam-Salomon an international reputation alongside that of Nadar himself—the first more formal and "sculptural," the second more natural and direct. Indeed, the styles of these photographers were diametrically opposed. Adam-Salomon photographed Camille Silvy with lavish elegance (frontispiece), a portrait in which the retouching on the print has become evident in the course of time, although any retouching on the negative remains, of course, concealed. Silvy inscribed the print to Martin Laulerie, administrator of the S.F.P. from 1855 until 1870; Laulerie in turn must have given it to the society, in whose collection it remains.

Nadar also left a memorable portrait of Silvy—his, as we shall find, was in

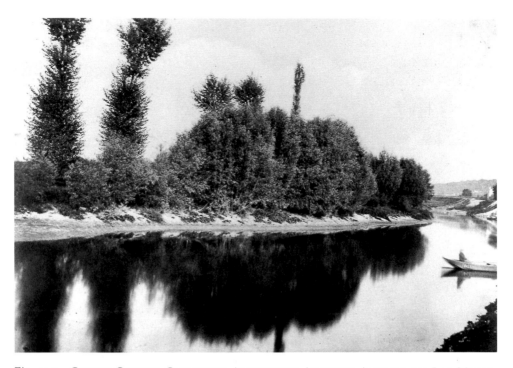

Figure 9. COUNT OLYMPE-CLEMENTE-ALEXANDRE-AUGUSTE AGUADO DE LAS MARISMAS (French, 1827–1895). *Ile des Ravageurs, Meudon*, circa 1855. Albumen print from paper negative, 27.9 × 39.9 cm (11 × 15¾ in.). London, private collection.

prose—and in a chapter on "The Primitives of Photography" sketches the heyday of the serious art of photography in France in the 1850s. One of the most notable "zélateurs," as Nadar called them, and one who bears on Silvy's story, was Olympe-Clémente-Alexandre-Auguste, Count Aguado. Second son of the marquis of Las Marismas, a Spanish banker who owned a great art collection (much of which is now in the Louvre), Count Aguado was taught photography in 1849 by Viscount J. Vigier. Aguado was a tireless amateur, inventor, and—in his turn—teacher. He was, in particular, Silvy's master.[53] Aguado pioneered the use of tastefully painted *grisaille* backdrops for portraits. Such backgrounds, "based upon some *objet d'art*, some graceful vase overflowing with flowers," might suggest that the sitters were "lost in reverie among the surroundings of one of their favourite parks"—as *La Lumière* wrote of Aguado's self-

28

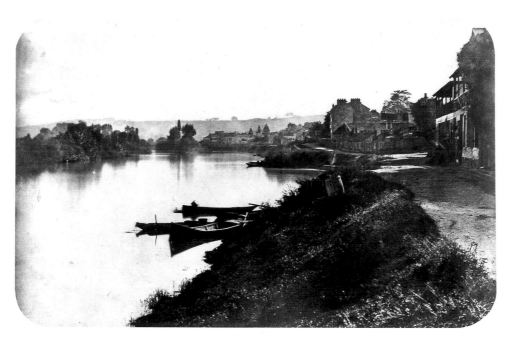

Figure 10. HENRI-VICTOR REGNAULT (French, 1810–1878). *Sèvres: The Seine at Meudon*, circa 1853. Carbon print printed by ALPHONSE-LOUIS POITEVIN (French, 1819–1882) circa 1855–60 from paper negative, 31.1 × 35.4 cm (12¼ × 16¹³⁄₁₆ in.). Malibu, J. Paul Getty Museum 92.XM.52.

portrait with his brother, Viscount Aguado. Such paintings "serve to complete these photographs and turn them into works of art." Aguado's negatives were considered so exquisite by Eugène Durieu that he was urged to exhibit them instead of his prints.[54] With Edouard Delessert, he devised the *carte de visite* portrait—already mentioned in connection with Disderi and a topic to which we shall return later. He won awards internationally for his studies of trees, animals, and landscapes, and his landscapes prefigure the later subject matter of Impressionist painting. About 1855, Aguado photographed *Ile des Ravageurs, Meudon* (fig. 9), with its pattern of poplars and their reflections—so pronounced, indeed, that they seem as heavy as shadows—toward which a tourist pulls his rented, numbered boat. Surely the reflection of the boat is so awkward that it suggests, like the massed tree reflections that are a large part of the point

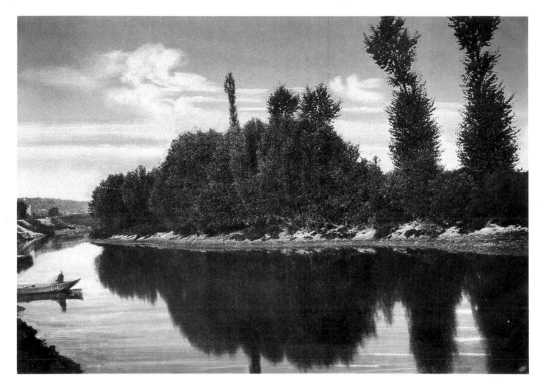

Figure 11. COUNT AGUADO. *Ile des Ravageurs, Sèvres*, circa 1855. Photolithograph after a photograph by Aguado, 27.3 × 39.5 cm (10¾ × 15⁹⁄₁₆ in.). Paris, Bibliothèque Nationale.

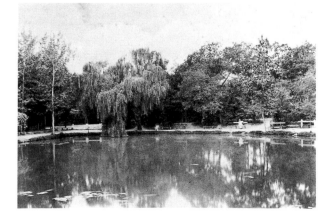

Figure 12. COUNT AGUADO. *Bois de Boulogne, mare d'Auteuil.* Albumen print, 27.6 × 39.5 cm (10⅞ × 15⁹⁄₁₆ in.). Paris, Bibliothèque Nationale.

of the composition, that Aguado—like Hanfstaengl and Adam-Salomon in portraiture—improved nature by painting on the negative. Notice, too, how the presence of a tourist adds a note that is not present in, for example, Henri-Victor Regnault's *Sèvres: The Seine at Meudon* of about 1853 (fig. 10). The boats in Regnault's photograph, while a contemporary accent, hardly alter our view of the river as "immemorial"—the river as raison d'être for the settlement on its banks. Aguado's Seine is already something very different: a place to be visited, for leisure, the island as tourist destination. The sense of malleability or play in Aguado's photography is heightened when we look at a photolithographic version of this landscape in which clouds have been added and the depth of perspective intensified (at the cost, of course, of reversing the motif) (fig. 11).

This interest in suburban sites and the theme of leisure was not a fluke in Aguado's work. Although comparatively little of his extensive production can now be traced, a number of prints survive of weirs and waterways at the edges of towns,[55] as does (directly on the theme of leisure) an astonishing photograph of a Paris park, *Bois de Boulogne, mare d'Auteuil* (fig. 12). The print is catalogued by the Bibliothèque Nationale as taken from a paper negative. Such prints are occasionally indistinguishable from prints made from glass negatives. However, the sketchy effects achieved from coarsely grained paper—an admired feature of the process—here reach an expressive extreme. The result suggests bright sunlight filtered through willow leaves before it strikes, first, the figures seated on park benches and, then, the water in front of them. Again, the theme is leisure, the relaxed enjoyment of sunlight, shade, water, reflection—reverie.

In November 1856 Nadar wrote to the S.F.P. to suggest that photography should be presented in the biennial Salon, which already included watercolors, drawings, engravings, lithographs, pastels, enamels, and miniature paintings. A committee of the society formed to consider this possibility included Eugène Delacroix, Théophile Gautier, Count Aguado, and other photographers and scientists of repute. The committee reported that photography's right to a place in the Salon was incontestable. The minister of state and director of the imperial museums, Count Nieuwerkerke, refused permission, but a compromise was reached in 1859. There was to be a Salon of photography, organized by the S.F.P., held in the same building and at the same time

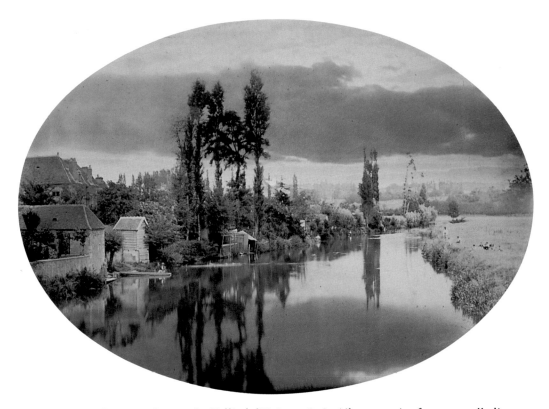

Figure 13. CAMILLE SILVY. *La Vallée de l'Huisne*, 1858. Albumen print from wet collodion-on-glass negatives, 25.7 × 35.2 cm (9¹⁵⁄₁₆ × 13⅞ in.). Paris, Société Française de Photographie.

as the Salon des Beaux-Arts.[56] Officials jealous of the status of the fine arts contrived to ensure that visitors who had seen the paintings and wished to see the photographs as well were required to descend to the street, enter by another door, pay a separate admission charge, and re-ascend to the first floor. (In 1861—great concession—a connecting door was opened at the end of the gallery of pastels, and on that occasion the Salon of photography was visited by the emperor, empress, and prince imperial.[57])

Camille Silvy was elected a member of the S.F.P. at a meeting held on March 26, 1858.[58] In May, Silvy—wrongly called "de Silvy" in the society's bulletin, as he was on several other occasions—was one of a number of photographers who donated

32

Figure 14. NADAR [Gaspard-Félix Tournachon] (French, 1820–1910). *La Peinture offrante à la photographie une toute petite place à l'exposition des beaux arts. Enfin! . . .* , 1859. Wood engraving. Reproduced from *Le Journal amusant*, April 16, 1859. Malibu, J. Paul Getty Museum.

prints to be sold to raise funds for the organization. His offerings were photographic reproductions of paintings and engravings.[59] In November 1858, he showed the society photographs, taken by the wet collodion process, of landscapes and animals.[60] In the following January, Silvy presented two portraits, taken by himself, and a landscape, "un paysage, d'après nature." Did Silvy simply show the society these works, or did he donate them?[61] If he made a gift, the portraits have disappeared, but the landscape may be the print of *River Scene, France* which belongs to the society to this day. In fact, the photograph is known in France by the title Silvy gave it when he exhibited it for the first time there, in the 1859 Salon, as *Vallée de l'Huisne* (fig. 13).

At the beginning of 1859, the society appointed a commission of judges to oversee arrangements for the forthcoming Salon. The commission included important scientists, members of the Institut de France, and photographers and innovators of the first rank, among them Hippolyte Bayard, Le Gray, Regnault, Louis Robert, and Aguado. The exhibition opened on April 1, occupying the first floor of the southwest pavilion in the Palais de l'Industrie (or Palais des Champs Elysées), an industrial palace of the Second Empire which set a standard of gracious amenity and functionalism.[62] Nadar drew his celebrated cartoon of painting and photography (easel and camera) strolling arm in arm to the Salon (fig. 14). Before long, Regnault, president of the society, was able to announce that the great success of the exhibition was to be re-

33

warded—on the authority of the minister of state—by an extension. To support their society even further, many photographers—including Silvy—offered to donate exhibits to be disposed of either in the annual sale of prints or by lottery.[63]

The enormous exhibition space was partitioned into courts, the four sides of which had "narrow counters, which serve as elbow rests, and for making minutes in the catalogues, while the visitor is examining leisurely the photographs hung above to the upright screens." As in Edinburgh, the hosts favored their own—or at least some of their rivals were less fortunate: "The contributions from England, Belgium, Russia, and Germany, are hung to the ordinary upright screens without the counters in front." While claret and gold probably decorated the walls behind Silvy's photograph in Scotland, in Paris "the covering of the whole of the screens and tables is of a glazed dark sea-green coarse calico, and forms a good background for the various tones of the photographs . . . which are, generally speaking, very well lighted, the roof over this gallery, of iron and glass, being at an altitude of upwards of ten yards."[64]

In general, each photographer had a separate display, the exhibitor's name "being wafered on to the middle frame." Over two thousand photographs were shown, and fatigue was "provided for by two bays of the colonnade next the nave being left open, so that the visitor may let the vision rove over the beautifully arranged garden occupying the whole of the nave, in which are arranged, with charming taste, the floral contributions to the show of the Horticultural Society, and the Statuary forming part of the Exposition des Beaux Arts; the whole making up a very agreeable picture of winding walks . . . plants, [and] rustic stepping stones across a running stream."[65]

"La belle collection de photographies de M. Camille Silvy mérite d'être spécialement mentionnée. Ses vues de *la Vallée de l'Huine* [sic], le *Château de Gaillard*, le *Pressoir*, le *Château de Nogent-le-Rotrou*, sont magnifiques"—thus the critic for *La Revue photographique*.[66] The praise for Silvy, so appreciative in Edinburgh, continued in his native country when the Salon opened—and he was not yet twenty-five. Adam-Salomon exhibited his portrait of Silvy, and Silvy himself showed twenty works, listed in the catalogue as: 1207 *Vallée de l'Huine* [sic], *Etude de moutons*, *Etang de Gaillard*; 1208 *Le Pressoir*; 1209 *Porte de l'église de Frage* (this should be *Frazé*); 1210 *Gué de La Croix-du-Perche*; 1211 *Cour de ferme*; 1212 *Château de Nogent-le-Rotrou, Eglise de Saint-Hilaire,*

*Mm de B***. Groupe d'après nature*; 1213 *S.A. le roi de Sardaigne, S.A. la reine de Sardaigne, Deux trophées de nature morte, L'Amour en visite d'après Hamon, Mme de V**. Portrait, Buse au vol, Portrait d'enfant, Portrait de l'auteur*; 1214, 1215 *Clichés négatifs.*[67] *La Revue photographique* concluded its appreciation of Silvy's display by commenting: "[T]wo beautiful negative plates complete this remarkable exhibition." Unless what Silvy actually showed differed from the titles given in the catalogue, *La Revue photographique* seems to have invented the photograph it titles *Château de Gaillard* by mixing up *Etang de Gaillard* and *Château de Nogent-le-Rotrou*. Although the usual losses have occurred, the first four items listed all survive, as does *Le Pressoir* (a cider press) and *Gué de La Croix-du-Perche*, possibly *Cour de ferme*, possibly the portrait of the king of Sardinia (in a *carte de visite* copy), and one of the brace of *Trophées de nature morte*—to which we shall return.

An English critic underlined the point that exhibits do not always correspond exactly to catalogue details:

> M. Silvy, member of the French Photographic Society, has exhibited a frightful-looking object—a portrait of the King of Sardinia. The next panel ought (according to the catalogue) to have contained a portrait of the Queen of Sardinia (which we should have looked at with more pleasure); but, probably terrified by the awful appearance of her husband, she has fled, and the panel is empty. On the other hand, M. Silvy's portrait of himself is one of the best photographs in the exhibition. It is a three-quarter portrait; he is standing in an easy position; he has a thick stick in one hand, and conceals the other in the pocket of a loose coat, the folds of which are admirably rendered. M. Silvy has exhibited a number of other proofs, which are not bad, but do not entitle him to a more special notice here.[68]

About Silvy, Ernest Lacan had something unusually interesting to say: "Among the landscapes, those of M. de Silvy [*sic*] must be cited in the first rank. It is difficult to obtain a greater finesse in the details with such grand and well combined effects of light. These are ravishing *tableaux* which have the merit of being as true as nature herself, while borrowing from art a glamour which gives poetry to the most ordinary places."[69] *River Scene, France* is, like the works by Aguado already mentioned, both an ordinary place and a most engrossing example of a new iconography.

Figure 15. NADAR. *Effet produit sur un visiteur du Salon par l'eau des merveilleux tableaux de M. Daubigny*. Lithograph. Reproduced from *Le Journal amusant*, July 16, 1859. Photo courtesy Aaron Scharf.

Edouard de Latreille, writing in *La Revue des beaux-arts*, derided the mean-minded arrangements at the Palais de l'Industrie that separated photography from the fine arts. The awkward access to the photography show would have been too much, he thought, for people who regarded the medium, in any case, as essentially a means of making one-minute portraits, and he felt that the S.F.P. should have stayed away from the Palais altogether. Echoing the *Times*' critic in London, Latreille argued that an able photographer needed the same training in perspective, chiaroscuro, and the rest as a painter. Without these, the whole world could not furnish a photographer with one landscape—but with them he could achieve true works of art. Latreille gave as examples *Vallée de l'Huisne* and certain works by Aguado and Fenton. To deny the artistic excellence of such works, he concluded, was merely bad faith.[70]

Several notable art critics wrote about paintings in the 1859 Salon but did not negotiate the circuitous route to the photographs. Interestingly enough, however, without mentioning photographs, several writers described the qualities of *River Scene, France* with striking accuracy. For example, Jules-Antoine Castagnary's praise for major paintings applies remarkably well to Silvy's photograph. In a picture by Théodore Rousseau, Castagnary wrote, "You can sit or walk, dream or think, just as you please. You breathe, you are alive."[71] Silvy was, however, stylistically closest to the river scenes of Charles-François Daubigny, whose *Bords de l'Oise* (Bordeaux, Musée des Beaux-Arts)

dominated critics' response to the Salon of 1859 and inspired Nadar's cartoon on the dangers of high illusionism in landscape art (fig. 15). Many river scenes by Daubigny from the 1850s display open foregrounds, startling naturalistic details, reflections, inviting spatial depth, trees, and settlements on the banks. The example closest to Silvy's photograph is *River Scene near Bonnières* (1857; San Francisco, Palace of the Legion of Honor). However, where Daubigny offered rural reveries, albeit with working herdsmen, Silvy presented the new subject of urban leisure.

A *Salon* (a popular journalistic form of the period) specifically on the *photographic* exhibition was written by Louis Figuier, a well-known science journalist. Having observed the exhibits with care, Figuier placed Silvy at the head of the modern French landscape school. He wrote:

> It is impossible to compose with more artistry and taste than M. Silvy has done. The *Valley of the Huisne*, the *Ford at La Croix-du-Perche*, the *Door of the Church at Frazé*, are true pictures in which one does not know whether to admire more the profound sentiment of the composition or the perfection of the details. M. Silvy has an excellent system for the production of his pictures which we should like to see generally imitated; he does not apply to all his landscapes, regardless, an identical sky made from a standard negative; whenever possible he takes the trouble to pick out, individually, the landscape view and that of the sky which crowns it. That is one of M. Silvy's secrets; but we cannot say what the others are, nor how he arrives at the science of composition which makes his works true pictures.[72]

Nogent-le-Rotrou and La Croix-du-Perche

CAMILLE-LÉON-LOUIS SILVY was born at Nogent-le-Rotrou in the department of Eure-et-Loir on May 18, 1834. He was the child of Marie-Louise, née Pied, and Onésipe Silvy, mayor of the town. Among the official witnesses of the birth required by law were two soldier uncles. We may suppose that the baby was named after his paternal uncle, Camille-Désiré Silvy, lieutenant of artillery in the Sixth Regiment. Antoine-Espoir Leroy, lieutenant in the Eleventh Infantry Regiment of the Line, was an uncle by marriage to Onésipe's sister, Reine-Amélie-Flore.[73]

Nadar noted that Silvy came from a distinguished French family and mentioned Italian ancestry.[74] The Silvy family were landowners and judicial or municipal magistrates in Cucurron (Vaucluse) and Aix-en-Provence at least as far back as the fifteenth century. As with many other notable Provençal families, there *was* a distant Italian origin. Sometimes the Italian version of the name—Silvi—was used, and family tradition refers to connections with the noble Sienese house of Piccolomini (and beyond to Silvius in Republican Rome). In the late eighteenth and nineteenth centuries, Camille Silvy's branch styled itself Silvy de Piccolomini, but this was never a legal title in France, and Camille himself is not known to have used it.[75] However, this exotic honorific may explain why he was sometimes called "de Silvy."

Camille's grandfather Pierre-Lazare-Léon Silvy had been born in Cucurron in 1762. He was a *négociant* (merchant) and, later, a lawyer in northern France, at Laon and then Lille. His son Onésipe-Tullius-Emile-Léon was born at Craonnelle (L'Aisne) in 1799. Onésipe Silvy trained as a lawyer in Paris, went to Nogent for his first job (aged twenty-six), and married Marie-Louise Pied. The daughter of a doctor, she is described on their marriage document as a *propriétaire*.[76] The couple lived in the Pied family house in the rue Dorée. Onésipe Silvy became the first non-native to serve as mayor of the town. Appointed by order of King Louis-Philippe, he served from 1832

to 1835.[77] Two daughters followed Camille, and gratitude for royal favor is evident in the naming of the younger of the two, Louise-Philippine-Hortense. The family owned a modest farmhouse, or *rendezvous de chasse*, and about five hundred acres at La Croix-du-Perche, eighteen kilometers east of the town in the direction of Proust's "Combray" (now known as Illiers-Combray in homage to him). The estate was called Gaillard, and the farmhouse, a single-story dwelling in the 1830s, was extended sideways and upward to become the handsome building that stands on the site to this day. It seems safe to assume that Camille Silvy made there the photographs he exhibited in the 1859 Salon under the titles *Cour de ferme* and *Le Pressoir*. (A couple of minutes' stroll from the farmyard is the millpond that appears in *The Pond at Gaillard* [fig. 16].) Silvy holidayed at Gaillard with his parents during his childhood and youth—and afterward.

Nogent-le-Rotrou is a market town fifty-five kilometers—about an hour's drive—west of Chartres (fig. 17). Its hinterland is Le Perche, hilly farming country famous for its Percheron horses. Nogent was of military significance in earlier times, and Château Saint-Jean, the castle of the Rotrou family, commands the locality from a hill above the town. Its imposing, ivy-hung masses were sketched by draughtsmen of the picturesque and photographed by Silvy. Antiquaries remembered the Nogent-born sixteenth-century poet Rémy Belleau and visited the tomb and mausoleum of the duc de Sully attached to the church of Notre-Dame. Nogent was a staging post on the route from Paris to Nantes on the Atlantic coast.

The river Huisne—"la Nymphe du Perche," according to an old historian—provided motive power for tanning, flour, and fulling mills.[78] Its valley also attracted the railway to Nogent when the route from Paris to the west was being planned in the early 1850s. The Grande Ligne de l'Ouest from Paris passed through Chartres, Nogent, and Le Mans on its way to Brest. The line was inaugurated, and the engines blessed by the bishop of Chartres, on February 12, 1854. The town had not been bypassed by progress. "Nogent is now a Paris district," wrote *Le Nogentais* the following day, ". . . only four hours from the capital!" The river was also important in the annals of the town. The first bridge had been constructed in the thirteenth century. It was replaced by a stone bridge in 1577. This was remade in wood, on the ancient piles, in 1857. (In the same year, the town bought and destroyed a fulling mill by the bridge,

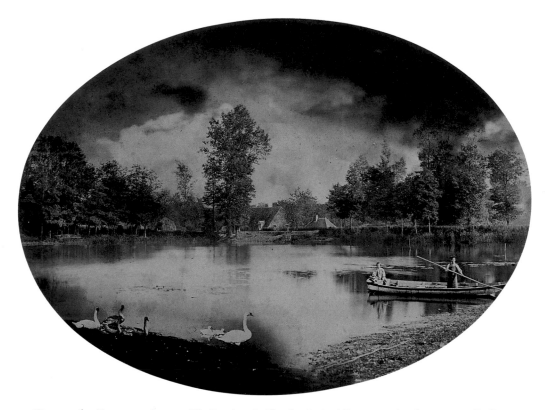

Figure 16. CAMILLE SILVY. *The Pond at Gaillard*, 1858. Albumen print from wet collodion-on-glass negatives, 25.6 × 35 cm (10¹⁄₁₆ × 13¾ in.). Nogent-le-Rotrou, Collection Musée Municipal du Château Saint-Jean. Photo: Pascal Barrier.

perhaps to make way for the new structure.) Although sometimes known as the Pont Notre-Dame or Pont Saint-Denys, the bridge was (and is) customarily known as the Pont de Bois—even though it was rebuilt in iron in 1883.

River Scene, France was taken from the Pont de Bois looking south and downstream. Just beside the bridge on the upstream side, several mills were driven by a subsidiary channel of the Huisne. Count Souancé, a historian of the town, mentioned some significant nineteenth-century dates: the creation of the Comice d'Agricole in 1836, various floods in the 1840s and '50s, the death of 117 in a cholera epidemic in

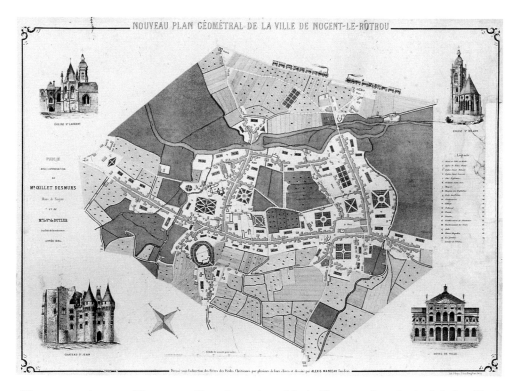

Figure 17. ALEXIS MANCEAU (French, active 1860s). *Nouveau plan géométral de la ville de Nogent-le-Rotrou*, 1864. Chromolithograph printed by F. Goyer, Paris. Nogent-le-Rotrou, Collection Musée Municipal du Château Saint-Jean.

1849, the planting of a "Liberty Tree" in front of the church of Notre-Dame in the revolutionary days of April 1848 (and its removal by order of the prefect of the department in March 1852), an earthquake in 1853, the inauguration in 1857 of a statue to General de Saint-Pol, who died in the assault on the Malakoff in the Crimea, the coming of gas lighting in 1865.[79] Jean-René Meliand, a pupil of David, taught in the town and painted a panorama from the top of the tower of Saint-Hilaire, which is a few hundred meters upstream from the Pont de Bois.[80] The population was just short of seven thousand in 1856.[81] When the railway was inaugurated, Paris newspapers congratulated the town on organizing spirited celebrations of the event—and on being "situated in a delightful position."[82]

Onésipe Silvy resigned as mayor when he was appointed director of a Paris bank, the Caisse Hypothécaire, in 1835. Camille Silvy presumably left the town with his family then or, as was sometimes the custom, when he was "bred" (at the age of two or three). However, it seems likely that he would have returned often on family visits and summer holidays, and perhaps more regularly after the opening of the railway. *River Scene, France*, his most famous photograph, was taken a few minutes' walk from his birthplace in the rue Dorée (now rue Gouverneur).

Silvy provided his own brief explanation of how he took up photography: "[A]s a child, I had as drawing master an artist who excels in painting military scenes, M. H. de Lalaisse, professor at the Ecole Polytechnique."[83] This must have been Hippolyte Lalaisse, teacher, lithographer, and painter of portraits, genre scenes, and animals, whose works include *La Bretagne* (ten lithographs, 1844), *Armée française* (188 images, 1840–60), and many other illustrated volumes on costume and horses.[84] Silvy was not educated at the Ecole Polytechnique in Paris, France's top training establishment for engineers and the military, however.[85] He actually studied law—graduating in 1852 and taking up a minor diplomatic post the following year. To return to his own account of his vocation:

> As a young man I made a trip with [Lalaisse], in 1857, to Algeria; when I realized the inadequacy of my talent in obtaining exact views of the places we traveled through, I dedicated myself to photography and, in order to carry out the program with which I had been honored by His Excellency the Minister of Public Instruction, I concentrated especially on reproducing everything interesting—archaeologically or historically—that presented itself to me.

Silvy photographed in Kabylia, newly conquered by France, and was thrilled to be in a place "where no Europeans had ventured since the Roman occupation." Perhaps his drawings and photographs from this campaign survive in a government archive.[86]

In 1859, Silvy lived at 10, rue Villedo, Paris, in the quarter between the Avenue de l'Opéra, the Bibliothèque Nationale, and the Palais Royal. Gabriel de Ruminé lived at the same address. It seems that this can have been no coincidence, for de Ruminé—like Silvy—joined the S.F.P. in 1858 and exhibited at the Salon the following

year. A Russian nobleman, he accompanied Grand Duke Constantine, son of Czar Nicholas I, on his voyage around the Mediterranean. De Ruminé skillfully photographed many monuments visited on his travels, using large negatives (approximately thirty-five by forty centimeters) and publishing prints that sometimes show the chamfered corners of the *River Scene, France* print bought by C. H. Townshend (fig. 6).[87]

Silvy also used a large camera, one that could take a negative of approximately twenty-five by thirty-four centimeters. The views he exhibited at the Salon were all probably taken close to Gaillard at La Croix-du-Perche or in Nogent-le-Rotrou, except for *Door of the Church at Frazé*. Silvy may have been able to use darkrooms in the family's houses and could have rigged up something temporary in an outbuilding at Frazé (the next village to La Croix-du-Perche). Otherwise, he would have needed a carriage converted into a "photographic van"—as Roger Fenton called his—or one of the newly designed handcarts in which photographers transported their apparatus, including a dark-tent. It seems possible that such mobile workshops gave the artist Daubigny the idea for his mobile painting studio, a boat he called *le Bottin*. The notion of making finished pictures on site, a new and typical idea of the midcentury, provides another close link between the practices of photography and painting in the 1850s. John Szarkowski has characterized the era of the wet collodion glass negative as essentially "conceptual": "The preparation and development of the wet plate had to be performed quickly in relative darkness, which meant the photographer was obliged to carry his darkroom with him wherever he hoped to work. A Dr. John Nicol later recalled that his own outfit weighed 120 pounds, and that some others were heavier. 'Of course, where the [dark-]tents were set up, there or thereabout the whole work of the day had to be done.' "[88] Szarkowski has offered another interesting formulation: "It is difficult to escape the conclusion that the triumph of the wet-plate system was won not on practical but on aesthetic grounds. There was, generally, no practical advantage in being able to count each mortar course in the brick wall of a distant building, but it was nevertheless a pleasure to look at a picture that allowed one to do this. It produced the satisfactory illusion that all was revealed, nothing withheld."[89]

That, surely, is the difference between Silvy's *River Scene, France* and the river scenes of Aguado and Regnault (figs. 9, 10), and it is the difference between the first

half of the 1850s and the second half. Astonishing as the paper negative could be in the brilliance of its rendition of detail, there was still nearly always a significantly greater sharpness available from the glass negative, as well as a dramatic gain in exposure speed. There are *people* along Silvy's riverbanks, and although they look as if they were there for the camera, they are not so much stiffened as steady, concentrated. They were positioned by someone, we might say, who was a deft arranger of the *mise-en-scène* of a photograph, posed naturally and yet strikingly. Philippe Burty wrote in 1859 that unpeopled landscapes were generally preferable to those in which people stood in constrained attitudes.[90] Though Burty was right, *River Scene, France* is made socially, psychologically, and compositionally more arresting by the figures. They also underline the relative instantaneity of the piece. One even waves a slightly blurred hand to the photographer on the bridge (fig. 18). (Perhaps Silvy raised his arm to indicate that the exposure was about to take place, and an inexperienced member of his staff—age—perhaps a child?—waved back.) As we shall see, Silvy is known to have made preparatory sketches for two street photographs involving groups of figures in 1859. He may or may not have sketched out *River Scene, France* in advance, but he must have choreographed the figures. It is impossible to be exact about the exposure time of this photograph. What is the likely duration of an impromptu wave of the hand? This question, although unsatisfactory, seems easier to answer than "How long does it take an unknown number of unspecified waterfowl to swim about ten feet?"

Questions also surround the cast chosen by Silvy to people his landscape. Madame Renée Davray-Piekolek, curator of nineteenth-century collections at the Musée de la Mode et du Costume, Paris, has examined *River Scene, France* from the point of view of clothing. On first seeing the picture, she suggested that the young couple on the left bank "belong to the rural bourgeoisie" (fig. 19), finding the costume of the young woman "rather elegant, and of an urban cut and style; she is corseted." Madame Davray-Piekolek's analysis continues:

The man wears a light-colored hat, trousers and shirt: these are not working clothes. On the right bank, farther away, one can make out a seated woman with a head-covering of the same kind as the first woman. The clothes of the sitting men are not sufficiently distinct. However, the man at the rear is wearing a light-colored overall, a hat, and a large

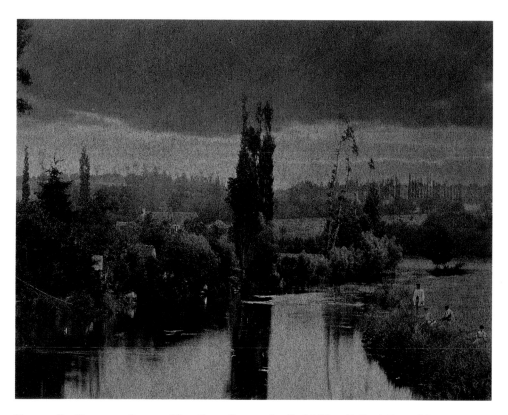

Figure 18. CAMILLE SILVY. *River Scene, France*, detail. Malibu, J. Paul Getty Museum.

flannel belt of the *ceinture de force* type worn by peasants and workers up to the 20th century. Is he a foreman from a nearby factory, and are these workers in Sunday dress? Whichever, this type of costume is more working-class [*populaire*] than that of the group on the left bank.[91]

On seeing enlargements of the figures, Madame Davray-Piekolek noted that the young woman on the left bank wears an apron over a long skirt: "Is this a domestic or the mistress of the house in working clothes?" The men on the right bank are wearing caps with short peaks, headgear "de type populaire par excellence" of the 1850s.[92]

One could, perhaps, with a list of the photographer's family circle, make some educated guesses as to who exactly posed for this picture. Engaging as that might be,

Figure 19. CAMILLE SILVY. *River Scene, France*, detail. Malibu, J. Paul Getty Museum.

it would miss the point, however. This is *not* a family portrait in a landscape, nor even an extended family portrait in an extended landscape. Apart from the juvenile leads by the boat (and they are not easily legible in detail), the figures are withdrawn to a distance at which it is impossible to read their faces or even to feel absolutely sure about each figure's clothes or class. As far as pictorial values or his public audience were concerned, these figures were surely *not* part of Silvy's family or biography. They were, for the purposes of this picture, indices rather than individuals, representing such classifications as youth and romance, age and patriarchy, childhood and spontaneity, male and female, individuals and the family group—plus contrasts between these values, such as males and the family group (notice the distance between the two clusters of

46

Figure 20. LEO DROUYN (French, 1816–1896). *Tour de Saint-Pierre de Luxembourg, à Ligny-sur-Ornain*. Wood engraving. Reproduced from *Le Magasin pittoresque* 26 (January 1858), p. 61. Malibu, J. Paul Getty Museum.

figures on the right bank). All of these values and contrasts are viewed under the larger headings of leisure and transience. A reading in terms of class would run on the lines of, say, private property (capital) represented by the young couple with the nice clothes, garden, and boat on the left bank, in contrast to the motifs of common ground, working-class (granted, they are in their Sunday best) labor represented by the mainly seated figures in the meadow on the right bank. A reading along these lines could be reinforced by such theoretical models as habitat theory, which we shall consider later. There is certainly more here than we find in the stilted groupings that diminish many landscape photographs of the 1850s.

If Silvy intended to represent a genuine social contrast, he brought out and complicated a rudimentary feature of topographic prints of the time in which the leisure of tourists is made more conspicuous by the workaday locals who ferry them to their viewing stations past kneeling laundresses and respectful cowherds. In this reading of *River Scene, France*, the privileged young things on one bank are about to enjoy a boat trip under the wistful gazes of the retinue of admirers on the other bank. The formula follows, but expands, what we find in engravings of picturesque spots in, for example, the long-lived and successful Parisian popular education magazine *Le Magasin pittoresque*. The arrangement is clear, for example, in Léo Drouyn's drawing of the Tour de Saint-Pierre de Luxembourg at Ligny-sur-Ornain (fig. 20). However, there is another possibility. Those who perused the lithographs in the local historian Edouard Lefèvre's volume *Eure-et-Loir pittoresque*, published in Chartres in 1858, found scenes

Figure 21. AUGUSTE DEROY (French, d. 1906) and A. BEAUJOINT (French, active 1852–67). *Maintenon: Vue des aquéducs*, published 1858. Lithograph, 9 × 14.3 cm (7½ × 5⅝ in.). Paris, Bibliothèque Nationale.

in which there is no such contrast. Instead, in *Maintenon: Vue des aquéducs*, for instance, an artist sits to sketch the very motif in the plate, surrounded by—it seems—his family and friends (fig. 21). This kind of picture could have provided a partial model for Silvy's scene. The actuality was probably the same—the young artist at work, watched by people who were happy to be told where to sit or stand and what to do, and on whose patience said young artist had some kind of claim.

Although it shares many features with views taken from river bridges in *Le Magasin pittoresque* or *Eure-et-Loir pittoresque*, Silvy's composition differs from such pictures in a significant way: it lacks any obviously picturesque building or monument. He took pains, in fact, to exclude a highly picturesque vernacular building, Romanesque castle, and handsome church. All of the buildings just mentioned would have been available if the photographer had elected to show us the view across the river rather than downstream. The local topographical painter Jean-Baptiste-Louis Moullin[93] did just that in 1861 (fig. 22). Moullin's canvas gives us the meadow in the foreground, plus a man (with a dog and, possibly, a fishing rod) whose tricorn hat confers historical resonance at the expense of credibility. The mill or storage building(?) with a steeply triangular elevation at the left was exactly excluded by Silvy. The main group of poplars in the photograph remains clearly visible, although reduced in importance, in the painting. The church of Saint-Laurent became Moullin's principal motif. The painting style, fussy but careless, contrasts with the comprehensive description and lack of "convention," as contemporary critics put it, in the photograph.

The lack of picturesque monuments in Silvy's photograph suggests that the

Figure 22. JEAN-BAPTISTE-LOUIS MOULLIN (French, 1817–1876). *Le Château Saint-Jean et l'Eglise Saint-Laurent vus depuis les prairies de la cascade*, 1861. Oil on canvas, 36×44 cm (14³/₁₆× 17⁵/₁₆ in.). Nogent-le-Rotrou, Collection Musée Municipal du Château Saint-Jean 1972.3.1. Photo: Pascal Barrier.

people we see are not tourists but residents. We might suppose that one at least of the young people on the left bank lived in the rue des Tanneurs, the street in which these riverside houses are situated, or at least enjoyed access to a garden and the use of a punt. Although the rue des Tanneurs owes its name to the mills on the upstream side of the Pont de Bois, shown in an 1874 drawing by A. Jubault (fig. 23), and must once have housed workers from the tanning mills, by the 1850s the population was mixed. It included the respectable and well-to-do, such as a *Juge de Paix*, a *Juge d'Instruction*, a

Figure 23. ALEXANDRE JUBAULT (French, active 1870s). *Les Moulins du Pont de Bois*, 1874. Collotype reproduction, 14.3×23.5 cm (5⅝×9¼ in.). Nogent-le-Rotrou, Collection Musée Municipal du Château Saint-Jean 1958.40. Photo: Pascal Barrier.

public notary, and the "Chef de Service des Contributions [Taxes] Indirect," as well as merchants in haberdashery and rabbit skins. More weavers and spinners than tanners were recorded on the street in the town census of 1851. As it happens, a Leroy—possibly a Silvy cousin—was also listed. But presumably entrée to these houses and gardens was hardly a problem for Silvy.

Silvy's scene has something of the atmosphere of a small-town beauty spot, and the figures on the grass—very different in significance and mood from the lonely oarsman in the rented boat photographed by Count Aguado at the Ile des Ravageurs (fig. 9)—look like natives taking the air. The site is still a local beauty spot today; a color photograph taken looking downstream from the Pont de Bois is featured on the town's current tourist brochure. But Silvy's photograph is more than a topographical view, however charming the motif. His picture is a tour de force of photographic delineation, achieved by a combination of astonishing depth and breathtaking width. It looks at first as if he achieved this effect by using a small lens stop combined with a wide-angle lens. There is no contemporary reference to the type of lens or camera he used to create his photographs of 1858–59. Many new landscape lenses came onto the market in the later 1850s. At first sight, the most compelling candidate, as far as *River Scene, France* is concerned, is the Voigtlander Orthoscopic lens. This newly offered lens, actually essentially the same as the Petzval Orthoscope of 1857, was examined by a commission of the S.F.P. early in 1858 and found to have exceptional light-gathering qualities. These allowed it to capture landscape pictures that combined "great sharpness" and very short exposure times (i.e., three seconds for a "landscape of ten-and-a-

quarter-inches, sharp to the edges"). The S.F.P.'s distinguished commission proclaimed the Orthoscope a marvel: "At present it may be pronounced the best combination known both for landscape and copying engravings." Furthermore, the commission emphasized its suitability for taking "*instantaneous* pictures of distant external objects." By a simple adjustment it could also be used for portraiture.[94] Kate Rouse, curator of the apparatus collections of the Royal Photographic Society, recently studied Silvy's photograph and made these observations:

> There are two qualities of the lens used to take this photograph which are of particular importance in determining the design used: its speed and the large, uniform area of sharpness. From the boy's arm in the right-hand group of people it can be seen that little movement has taken place during the exposure, implying that a relatively short time was used. Hence it is a reasonable deduction that the lens must have been used at a large aperture. However, the image has not lost its sharpness towards the edges and so the lens must have had good definition, over a large plate size, even when used at around full aperture. In my view this discounts any of the meniscus type lenses which were available to Silvy, as they could not produce a large, sharp field unless well stopped down (to at least f/30 according to D. van Monckhoven's *Photographic Optics* [1867]). This leaves only two basic designs available to him prior to the summer of 1858 that might have been able to produce this photograph. One is the Orthoscope and the second is the symmetrical design, of which there are many examples, some better than others.

Rouse concluded: "This picture may have been taken either with a Voigtlander Orthoscope of Petzval's design or a good quality lens of symmetrical design, and I am unable to determine with any degree of certainty which it might have been."[95]

Silvy's *River Scene, France* may appear to have been taken with a wide-angle lens, but this effect results in part from the optical effect of the oval format. A rectangular mask placed over the photograph establishes a quite different general impression. The clouds—as they do in the photolithographic version of Aguado's *Ile des Ravageurs* (fig. 11)—greatly accentuate the perspectival depth. The difference clouds make to a landscape was well described by a contemporary critic: "A sky should convey the effect of *space*, not *surface*—the eye should gaze *into*, not upon it—and instead of coming forward and throwing back every other object it should retire and bring the landscape

into prominence."[96] The clouds also imply the transience of this one moment. The trail left by the invisible waterfowl also underlines, with a touch of comedy, the sense of an *instant*. We should accept the trail as part of the finished picture rather than as a flaw that could not be covered up or undone by judicious retouching. The swirls and streaks vouch for the instantaneity and authenticity of the production.

Landscapes without skies—with only a uniform white tone above the ground—were found wanting by critics. They lacked atmosphere. But the blue-sensitive negatives of the time made landscapes with skies an almost impossible challenge, as Lady Eastlake vividly described. It was even trickier than she said, because clouds were not all "burnt-out . . . in one blaze of white"; the sky could actually resemble, as Ernest Lacan put it in an essay on the problem, "blackish stains."[97] We have already heard from Louis Figuier how Silvy solved this problem. He photographed a landscape and photographed an appropriate sky separately, on separate negatives, and probably on different occasions and in different places. He joined landscape and sky at the printing stage.

This method had been thought up by the French pioneer Hippolyte Bayard and first published with considerable excitement by Lacan, writing in *La Lumière* for August 7, 1852. Having made separate negatives of ground and sky, Bayard cut paper masks that enabled him to print the two parts of the picture consecutively on one piece of printing paper. His method became accepted practice. A description of the technique, published in England in 1863, suggests that the procedure was fiddly and laborious in practice:

> [T]he sky must be cut out with a pair of scissors to within one-eighth of an inch of the outline of the picture; this will form a mask for the sky; a mask must next be cut for the landscape, making it rather smaller by cutting it one-eighth of an inch within the outline. These masks must be exposed to the light till they are blackened; they are then washed to remove the free nitrate, and dried. We now gum the mask on to the sky on the varnished side of the negative, so that there will be one-eighth of an inch left between the edge of the mask and the outline of the landscape: the interval is to be filled up with Indian ink laid on with a camel hair brush.

The procedures were repeated for the landscape negative.

> When the painting is done, lay the paper mask on the landscape, allowing it just to over-
> lap the lower edge of the paint, gum it on either side to the part which will be trimmed
> off, next lay the sensitized side of the print on the sky plate, hold them up between the
> light and the eye to ascertain that the right part of the plate will print on to the picture,
> place them carefully in the pressure frame, and print as from an ordinary negative. On
> removal from the frame place the print in a dish of water to remove the free nitrate and
> the Indian ink: as soon as the gum has become soft, remove the mask and put by for the
> next print.[98]

Another writer, V. Blanchard, counseled that "the most beautiful studies of clouds are produced when the camera is pointed towards the sun, for greater contrasts of light and shade are seen. Cloud negatives so taken, however, can, unfortunately, seldom be used, for in landscape photography the operator is not often so daring as to work with the light in front, and of course such negatives can be used only when the landscape is thus lighted."[99] Silvy followed this advice for the clouds in *River Scene, France*. The landscape was photographed, it seems, on a day of bright light diffused by haze.

Bayard's method gave the photographer something of a painter's freedom, Lacan wrote, and he suggested ways in which landscapes and clouds could be poetically combined. He imagined that if the photographer had portrayed the minutely detailed panorama of a town rising gently, slope by slope, on the flanks of a hill, he would choose a grandly drawn cloud simply to attract the eye upward and to contrast in form with the details of the landscape or monument below: "Lighter or stronger tones of the clouds, harmonizing or contrasting with the general tonality of the work, will give it great merit."[100] This describes Silvy's technique in *River Scene, France*. And yet the photograph is still puzzling.

Some years ago the present writer sought the guidance of the great interpreter of the American landscape and virtuoso of camera and darkroom technique, Ansel Adams. Mr. Adams was kind enough to write at some length about this picture, basing his remarks on a poster of the print in the Victoria and Albert Museum, reproduced fairly accurately by offset lithography in the early 1970s. Adams's letter is dated Oc-

tober 3, 1982, and includes this extraordinarily sharp-eyed analysis: "You will note that there is a dark value in the trees above the bottom cloud line. This indicates that the masking was not adequate in this area (it is not apparent in the trees to the right)." He also detected "something 'phoney' about the light-edged clouds along the horizon; they look to me as if they were retouched in." Adams also thought that "the little shed on the left looks dodged or 'bleached.'" He pointed out that "there is no reflection of the clouds. The water foreground has been burned-in and the roof of the little shed is in the area of the main burn-in, and consequently darker than expected. . . . The right-hand side of the picture is in a different light from the left-hand side. There is a definite 'dodging' area above the roofs on the far left." Adams concluded: "It is *pretty good* optically. The 'old boys' did some remarkable 'cut-and-paste' jobs; I am surprised that the green foliage comes through so well. . . . Apparently it was quiet water and very little wind (if any)."[101]

Silvy, like Adams, is recognized as one of the great craftsmen of photographic printing. He used the generally preferred materials of the time—the wet collodion-on-glass negative and albumen printing paper—and, at least at the beginning of his career, there are grounds for thinking that he used gold chloride, or *sel d'or*, toning. The collodion negative in combination with relatively glossy albumen-coated paper (introduced by Blanquart-Evrard in 1850) produced that tack-sharp rendition of reality beloved of photographers and critics. Gold-chloride toning intensified a print and enhanced the coloration to a cool brown, purple, or bluish black. It also preserved the image extremely well—unless, that is, something went wrong. James M. Reilly has written that "in fact, the usual practice of *sel d'or* toning involved a fairly good chance that sulphur toning and the release of potentially destructive invisible sulphur would take place before gold toning was fully accomplished . . . some *sel d'or* toned prints faded very quickly and others last to this day as vigorous as the day they were made."[102] By 1860, the evidence against this procedure was conclusive. The alkaline gold toning method of J. W. Waterhouse, which separated toning and fixing, was generally adopted.[103] It is interesting to note that the prints Silvy is likely to have made before 1860 are much less consistent than those he made after that date. It is at least reasonable to conjecture that he used *sel d'or* toning in 1858–59 and alkaline gold

toning thereafter.

The magnificent inconsistency of *sel d'or* toning may help to account for the extraordinary differences to be found in surviving "states" of *River Scene, France*. We have so far looked at two prints—that in the Victoria and Albert Museum (hereafter State 1) and the S.F.P. print (State 2). Let us put them side by side (figs. 24, 25). The foreground is burned in in State 1, but there is cloud detail in the foreground of State 2. The cropping is different. State 1 has chamfered corners, while State 2 is a pure oval. Cropping of this kind was common practice when the resolving power of the lens fell away distractingly at the corners of the plate. State 2 is also cropped tighter, omitting the (untidy? confusing?) roofscape, chimneys, and some of the shrubs or fruit trees at the left edge of State 1. On the right edge of State 2, more foliage appears than in State 1. The main difference is that the figures and the view are brought closer to us in State 2. But the sky has moved as well! Several years ago, this writer began to think that there was something a little soigné about the way the tallest poplar nestles in an obliging kink in the cloud above it in State 1. That is altered in State 2. Ansel Adams drew attention to the "dodging" area above the roofs on the far left (fig. 26). The sky is too bright here—unless this sky has two suns (the other being behind the light cloud at the top right)—and—tell-tale sign—the definition of the ridge tiles on the roof has been softened. Compare the crispness of the ridge tiles on the buildings lower down in the picture. Adams also suggested, surely correctly, that the "elegantly drawn" line of cloud which traverses the horizon at the photograph's right edge was actually drawn freehand by Silvy on the negative (fig. 27). Adams was right too about the main group of trees being too dark because of an error in masking. The trees are darkened because they have the darkness of the cloud printed behind them plus the printing they received as part of the landscape. Hence (once one has begun to analyze the picture) their relative heaviness compared to the other trees. The cloud area apparently reflected in the foreground of State 2 must have been printed in from a third negative or *painted* on the lower/landscape negative. There is much more to the picture than the conjunction of two negatives.

Look closely at the band of somewhat muddy tone along the horizon (fig. 28), a zone that continues across that level of the picture. Silvy drew his handsome cloud

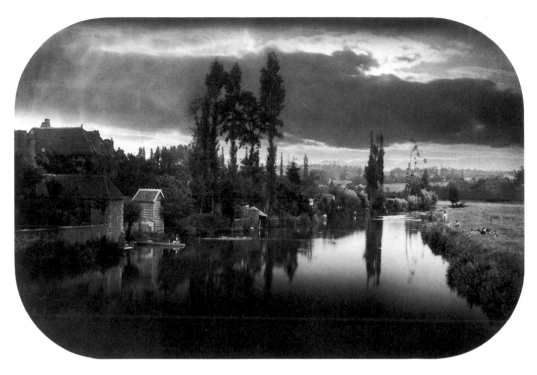

Figure 24. CAMILLE SILVY. *River Scene, France* (State 1). London, Victoria and Albert Museum.

line along it freehand as a means of disguising this somewhat leaden area of the composition, as a means of suggesting atmosphere, perspective. Even Le Gray had problems in that zone of his marines at which restless seas meet—sometimes abruptly—the flat tone of the lower sky (*beneath* the dancing clouds). Silvy also painted among the main stand of poplars, and if we look closely at the trunks of the trees, we see how the photographer compensated for his painting-out by adding in little dabs of foliage. This is even more evident further up the leftmost tree, where there is a free splash of foliage. Between this tree and the rooftop to its left is an area of open, "dodged" sky into which poke two or three distant treetops. *Behind* these trees is, once more, the flat tone Silvy was at such pains to disguise. So *River Scene, France* is a combination of two negatives (*possibly* a third for the sky reflection) and a considerable amount of hand-

56

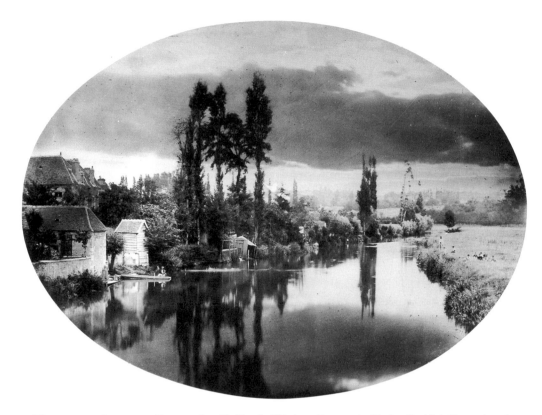

Figure 25. CAMILLE SILVY. *La Vallée de l'Huisne* (State 2). Paris, Société Française de Photographie.

work—probably on both landscape and sky negatives. State 1 is, of course, also burned in along the top edge.

A valuable treatise was discovered by François Lepage of Gérard Lévy's gallery, Paris, and a fascinating extract was later published by André Jammes and Eugenia Parry Janis in *The Art of French Calotype*.[104] The treatise by Ele. (Estelle?) Pinot, "professeur de peinture et de photographie," was published in Paris in 1857 with this title: *Photographie-Ivoire ou l'art de faire des miniatures rendu aussi facile que le coloris sur plaque sans savoir ni peindre ni dessiner, precédé d'un traité complet de photographie, contenant les procédés nouveaux pour faire des fonds de paysages, les ciels, etc. etc.* This treatise is a convenient cod-

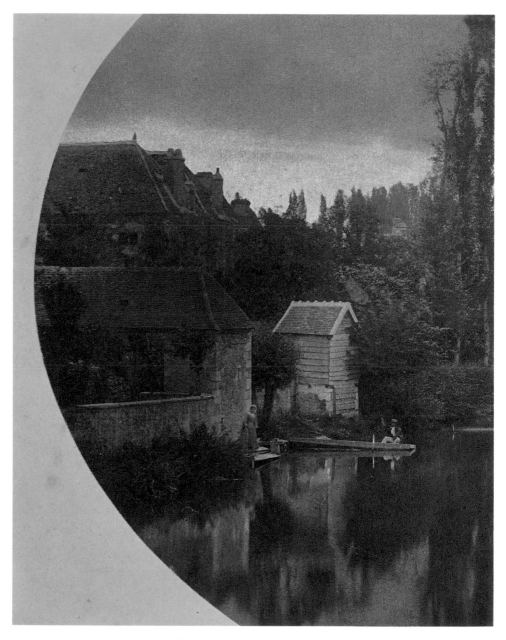

Figure 26. CAMILLE SILVY. *River Scene, France* (State 3), detail. Malibu, J. Paul Getty Museum.

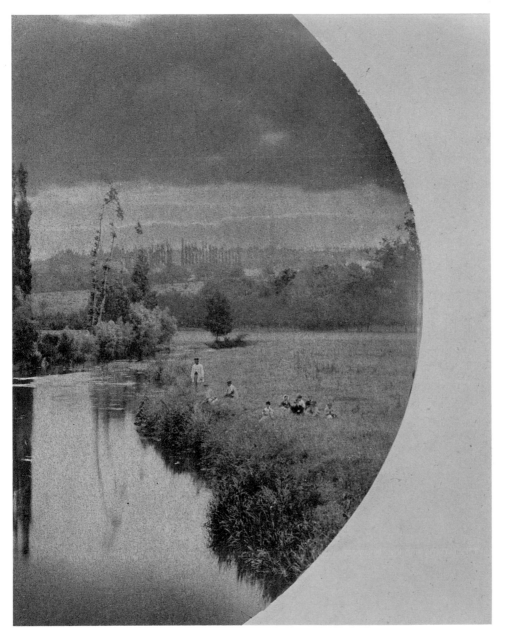

Figure 27. CAMILLE SILVY. *River Scene, France* (State 3), detail. Malibu, J. Paul Getty Museum.

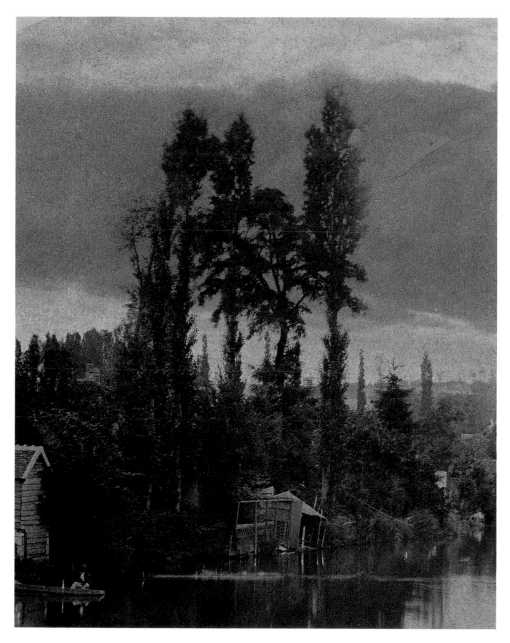

Figure 28. CAMILLE SILVY. *River Scene, France* (State 3), detail. Malibu, J. Paul Getty Museum.

ification of what was already widespread photographic practice—used by Adam-Salomon in portraiture and Aguado in landscape, for example. A negative was placed securely between the worker and the light so that it was as transparent as possible:

> With very finely applied india ink, it is extremely easy to carry out delicate work on the negative that will be shown on the positive exactly as if it had been obtained purely photographically.
>
> If there are trees in the background, one can lightly stipple in leaves of any shape desired. Gray stipple will allow a modest amount of light to pass through it and thus preserve the harmony of the photograph. This would be lost if the color were too thick and did not allow the light to pass through. One would then have a multitude of little white points of light which would be more disagreeable than otherwise.

These are the methods Silvy used, sometimes elegantly, sometimes less so, to enliven foliage. For clouds there were other methods. The negative was thoroughly cleaned and dried. Then a wax taper with a long, narrow flame (the taper known as a *rat de cave*) was—at a safe distance—waved dextrously to and fro beneath the negative. The sooty forms—delicate, soft, and even "imaginative"—were then varnished. Silvy may have used this method to create the whites in the sky at the top of his picture and the whites in the sky reflection at the base of State 2. The author advised that it could also be used for blossoms, leaves, etc. Silvy seems to have taken a pencil to the dense foliage immediately above the trellis beside the leaning boat house. He could have used this method to lighten the little shed which Ansel Adams thought might have been bleached, but could he have executed this skillfully enough to keep all the lines and textures of the structure looking so photographically convincing? This seems unlikely.

State 1, presumably from 1858, is signed *C. Silvy* on the mount in red ink. It is very richly toned, giving it the purplish black coloring that was considered very typical of French photographs in the 1850s and that derived principally from the practice and teachings of Gustave Le Gray. Le Gray explained the different colors that would be seen as an image was printed out by sunlight:

> These are the different colors it will successively take;—greyish blue, neutral tint, violet blue, indigo, black, bister black, sepia, yellow sepia, yellowish red, greenish grey, always

more and more powerful, until the oxide of silver is reduced to the metallic state. When you arrive at the color you desire, you must stop the process; for example, to have the proof of a black tint after fixing with the hyposulphite, you must stop the process at the sepia color; and the parts which should form the whites, at the greyish blue, in order to repair the loss of color it sustains by the application of the hypo. bath.

Le Gray always took care to leave a border—of both negative and printing paper—outside the printing frame so that he could accurately judge the action of the light. By such means was a photographer able to match the upper and lower halves of a print made from two negatives.[105]

State 2, presumably from 1858–59, bears the facsimile signature *C. Silvy* stamped on the mount in red ink. The print appears to be less heavily toned than State 1 and in consequence is a little faded. The color is cool brown rather than purple. The picture has suffered two small tears near the center. The watermark of the French photographic suppliers Marion & Co., who operated in Paris and London, can be seen across the foreground. This suggests that Silvy preferred French papers, as we should expect.

What we will call State 3, the print in the Getty Museum, is signed with a red facsimile signature stamped on the mount (cover, fig. 1, foldout p. 122). The clouds have shifted back to a position close to, but not exactly identical with, their position in State 1. More cloud detail is visible at the top of the sky than has survived in the other states. Cloud reflections in the water follow the treatment seen in State 2. The cropping of the overall composition follows that of State 2. The photograph is distinguished by its pronounced reddish brown tone, and the print has a markedly granular quality.

State 3 is the most enigmatic of the surviving prints. Questions of Silvy's intentions and methods are—in the absence of other evidence—likely to remain open. However, some speculations are offered here. Let us recall Count Aguado's astonishingly grainy—and tantalizingly undated—"Impressionist" print *Bois de Boulogne, mare d'Auteuil* (fig. 12). Let us also remind ourselves that Aguado was, in Silvy's words, "my photographic master." "It is to him," wrote Silvy in 1861, "that I owe the first principles of that art which he practices with so much honour, and which he so nobly patronizes. His counsels have ever been as precious to me as his friendship has been dear."[106] Apart from this essay in Impressionist print-making, Aguado made a series of

landscapes in the Berry which possess a vivid red tint.[107] In 1859 Niepce de Saint-Victor exhibited and promoted new methods of making prints in colors including red.[108]

Much contextual material—such as Silvy's negatives, work prints, and papers and those of Aguado—must be presumed lost. We are left with speculations. One of the most intriguing has been suggested by Weston Naef, Curator of Photographs, and David Scott, Research Scientist, Getty Museum, who analyzed State 3 by X-ray fluorescence (XRF) along with control samples by Gustave Le Gray and Julia Margaret Cameron. The analysis established that *mercury* is present in State 3 in relatively high amounts. Mercury is not present in the Le Gray or Cameron pictures, which represent typical albumen prints from France and England of Silvy's period. However, mercury is also found, in unexpected quantities, in the grainy, reddish brown calotypes made by the Scottish photographers David Octavius Hill and Robert Adamson in the 1840s. It can be speculated that Silvy used some kind of toning agent that was not in general use.[109] A clue to this procedure is given in a standard manual of the time by Robert Hunt. Hunt refers to the use of mercury in the making of negatives and prints, "very fine pictures, the intensity of which it is almost impossible to go beyond." However, "most unfortunately they cannot be preserved. Every attempt to fix them has resulted in the destruction of their beauty and force."[110] Naef has also pointed out that State 3 is mounted on "a quality and type of heavy lignin paper [that] suggests the print could have been made not in the late 1850s, but rather in the mid-1860s, when the Barbizon School of landscape began to give way to Impressionism. State 3 may be interpreted as an experimental response to changing artistic styles."[111] Mercury toning may have been chosen by Silvy precisely to achieve the strikingly grainy image structure of this print. Or was the granularity an accident he chose to regard as a happy one? Did the grain appear *after* he had signed the print with his stamp? Or did it appear as the result of unknown chemical/environmental conditions in the photograph's long period of obscurity between the date it was made (in the 1860s, or even 1870s?) and the date of its reemergence in the later 1980s?

What we shall call State 4 (fig. 29) is located in Nogent-le-Rotrou itself. It is identical in composition to State 2 but differs in condition. It was given to the town's museum in the Château Saint-Jean by a Monsieur Filleul, a former town councillor, ex-

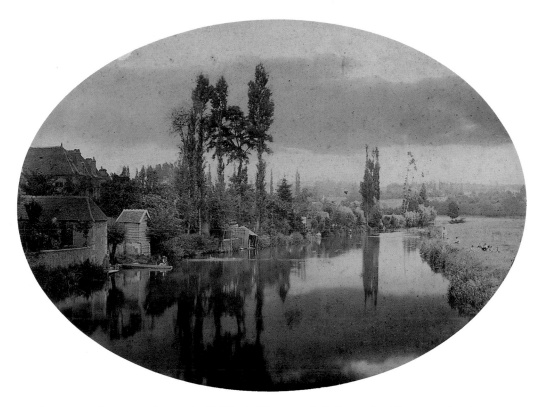

Figure 29. CAMILLE SILVY. *La Vallée de l'Huisne*, 1858 (State 4). Albumen print from wet collodion-on-glass negatives, 25.7 × 35.4 cm (10⅛ × 13¹⁵⁄₁₆ in.). Nogent-le-Rotrou, Collection Musée Municipal du Château Saint-Jean. Photo: Pascal Barrier.

actly one hundred years after Silvy took the photograph (inv. 1958.192). The print, an albumen print, is badly faded, but perhaps it has been faded for a long time. It is stamped in red ink with Silvy's facsimile signature. On the back is a fascinating label printed with this information: *PUBLISHED BY V. DELARUE. 10 CHANDOS STREET, COVENT GARDEN—LATE SIGNORI CALDESI AND MONTECCHI. PHOTOGRAPHIC STUDIO—38 PORCHESTER TERRACE, BAYSWATER W.* The *W* stands, of course, for the west London postal district, and the label shows that State 4 was published commercially in England, presumably not long after Silvy took over the Caldesi and Montecchi studio in August 1859, as we shall see. Given that the image was available in

this way and so well known in 1858 and 1859, it is surprising that only one print (that now in the Getty Museum) appears to have been offered for sale in the last few years. Gérard Lévy has seen no other print of Silvy's masterpiece in the trade in thirty years.

There is a second large-scale Silvy landscape in the Château Saint-Jean, the mount bearing his stamp and—on the reverse—the same publishing details as the *River Scene, France* in the same collection, plus the title and date *Etang de Gaillard à La Croix du Perche 1858* (fig. 16). It is in perfect condition. This must be the composition Silvy sent to the Photographic Society of Scotland Exhibition in 1859 under the title *La Mare aux cygnes*, "a delicately handled and beautiful landscape," according to the *Daily Scotsman*.[112] The composition was printed, it appears, from portions of three separate negatives: one for the general landscape, a second for the sky, a third for the swans. The second and third negatives would obviously have been taken at faster exposure times than the first. Silvy's handwork on the negative is obvious on the foliage at the left. The pond fed the flour mill at Gaillard and is only a field away from the farmyard. Was this the *Landscape* exhibited in London in January 1859? The uncertain nature of the sky (was it painted, rather than printed from a second negative?) suggests this possibility.

The only other large landscape by Silvy known to survive is another view of the pond at Gaillard (fig. 30). This print, signed on the mount in faded black ink in Silvy's hand, was bought by the Victoria and Albert Museum in the trade in 1985. It shows the mill at Gaillard, the sluice and rushes—delineated with skill similar to that of *River Scene, France*—and signs of forestry and other activity nearby. In a brief manuscript list of works dated 1859, Silvy refers to one of his photographs as *Moulin*, the probable title (if only a shorthand one) of this picture.[113] *Moulin*, or *The Mill at Gaillard*, adds to our sense of Silvy's working methods, because the reflection of the tallest tree is surely the result of handwork on the negative and must have been executed for compositional reasons. Recalling the manipulated tree reflections in Aguado's *Ile des Ravageurs* (fig. 9), it is another significant link between Silvy and Aguado. The sky is interesting here. It was not printed from a second negative but by "shading," a technique widely used in the 1850s. After the landscape was fully printed, it was removed from the printing frame and covered with a larger piece of card. The card was moved

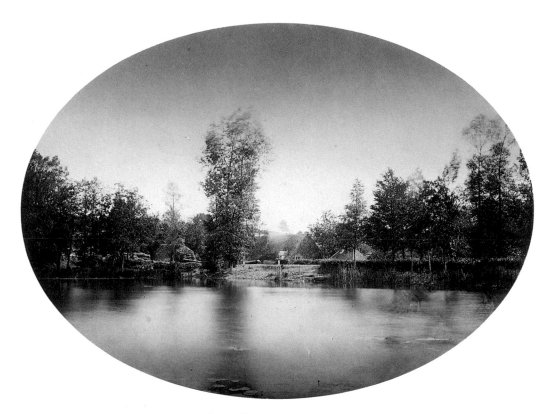

Figure 30. CAMILLE SILVY. *The Mill at Gaillard*, 1858–59. Albumen print from wet collodion-on-glass negative, 25.4×34.7 cm (10×13⅝ in.). London, Victoria and Albert Museum.

about in diffused light, not being allowed to remain stationary for a moment. This gave the sky a subtle gradation of tones and improved the illusion of depth.[114]

A recently discovered still life by Silvy, presumably one of the two *Trophées de nature morte* exhibited in 1859, once again betrays the photographer's retouching of the negative. It is a still life of *trophées de chasse* (fig. 31). The board against which the pike and game birds are displayed is chalked with the initials *C.S.* and the name of the family's *rendezvous de chasse*, Gaillard. Is retouching apparent in the shadows of the birds' pointed wings? Surely more works by Silvy—other prints of *River Scene, France*

Figure 31. CAMILLE SILVY. *Trophées de chasse*, 1858. Albumen print from wet collodion-on-glass negative, 23.2 × 17.1 cm (9³/₁₆ × 6⅝ in.). London, Victoria and Albert Museum.

and those landscapes at present known only by name—will reappear. The next chapter will introduce two such new discoveries: fifth and sixth states of *River Scene*.

Paris—London—La Croix-du-Perche

AT ODD MOMENTS DURING THE 1850S AND '60S, Camille Silvy kept a scrapbook. Into it he pasted drawings by himself, his friends, and his mother, or little prints of genre scenes. He sometimes wrote about his activities. The Monnier family, his descendants, very kindly showed me this album, together with the "curriculum vitae" compiled by Silvy sometime after 1871.

Silvy's description of his life shows that he visited England as part of his diplomatic duties in 1854, and a playful caption to a portrait suggests that he became enamored with a young lady from Birmingham. He also pasted into the album a photograph inscribed *Mathias Montecchi, London 1854*. This was surely the partner in the celebrated firm of Caldesi and Montecchi whose enormous reproductions of Raphael's cartoons dominated the photographic exhibitions of 1858–59. In 1859 Silvy resolved to record his photographic activities. One entry, headed *M. Bidaux*, is followed by a list of photographs. Were these sales to a collector? Or was Bidaux a dealer, or was he organizing an exhibition? He was interested in these photographs by Silvy: *3 portraits, 1 Vallée, 1 Gué, 1 Moulin, 1 Moutons, 1 Etang, 1 p.s. [Pressoir?]*. The reader will recognize all of these titles. *Moutons*, which exists in prints at the S.F.P. and in the Victoria and Albert Museum, relates very closely to animal studies by Aguado that were exhibited in the S.F.P. exhibition in 1857. The latter must have inspired Silvy to pose farm animals in order to photograph them, their necks and heads in obediently symmetrical formation, in front of a barn door.[115] In 1859 Silvy wrote a rare longer entry in the scrapbook about his photograph *The Emperor's Order of the Day for the Army for Italy* (fig. 32). Napoleon III had sailed for Italy to join the army he had sent to drive the Austrians out. He reached Genoa on May 12, 1859. Soon afterward, he drafted an *Ordre du Jour* addressed to the army and—a typical touch—arranged for the text to be telegraphed to Paris, printed overnight, and posted in the streets. This gesture, bringing the home population into direct contact with military events on the eve of war, appears to have had the effect the emperor desired. The weekly magazine *L'Illustration*

Figure 32. CAMILLE SILVY. Page from a scrapbook with entry describing *The Emperor's Order of the Day* . . ., approx. 20.5 × 28 cm (8¹⁵⁄₁₆ × 11 in.). Paris, Monnier family.

carried a story about it on May 21, commenting on how the emperor's soldierly orders to his troops had impressed the citizens in the *faubourgs*, who read his words even before they had been inserted in *Le Moniteur*, the official government mouthpiece. There was a strong political implication behind the appearance in the capital—unexpectedly, instantaneously, and at dawn—of the emperor's order. It was a moment that combined high technology, new politics, and history in the making.

Silvy recognized the moment's significance. He drew a typical group of Parisians looking at the emperor's placard and made a photograph that is similar in composition (fig. 33). Perhaps he drew the scene from life, as a study, and later composed

Figure 33. After CAMILLE SILVY. *Reading, in the Streets of Paris, of the Order of the Day Addressed to the Army for Italy*, 1859. Wood engraving after a photograph. Reproduced from *L'Illustration, journal universel*, May 21, 1859. Malibu, J. Paul Getty Museum.

a group of willing participants before his camera? He could equally have drawn the composition in his studio, based on things seen and heard. He sketched a second composition, "La scène du depart," which—his notes tell us—he did not execute. However, the first of the two scenes met, the scrapbook explains, with astonishing success. Count Aguado himself took a print to the empress. Other prints were taken to Goupil's, the leading publisher and retailer of prints, and sold rapidly, the first three being bought by the British ambassador. The photograph was also reproduced by wood engraving to illustrate the story published in *L'Illustration* on May 21.[116]

With his work simultaneously admired at court, sold by Goupil's, published as journalism, *and* exhibited at the Salon, Silvy—still only twenty-four—surely thought his hour had struck. He was also, he recorded in the same note in his scrapbook, "officially appointed photographer to the army." However, bureaucracy delayed. While waiting to receive his *ordre du depart*, he started to compile a history of the campaign based on bulletins in the newspapers. Much later, when he began to write the history of another campaign, that of 1870–71, Silvy recalled that he had been commissioned "to accompany the emperor on the Italian campaign, and to gather—with special instruments—the topographical and memorial [*nécrologiques*] information

70

which is so useful to historians."[117] The speedy success of French arms meant that the Austrians had met defeat at Montebello, Palestro, and Melegnano before Silvy received his papers. He reached Italy soon after Melegnano, and the first regiment of the Zouaves—which had suffered severe losses—provided a canteen wagon for him to convert into a laboratory (*laboratoire*—presumably a darkroom). However, Silvy soon reached the conclusion that it was not in the middle of a military action that such records should be made but afterward, when the combatants' positions could be studied and their memories consulted. He was, however, to ponder the equipment required for photographic records of war and to make experiments and inventions when hostilities with Prussia began to threaten a few years later.[118]

Stuck in Paris at the beginning of the Italian campaign, Silvy was able to witness an event that proved to be of great importance to the public relations of imperial power, to the social life of the nineteenth century in general, to the development of the photographic medium, and to his personal career. According to Olive Logan, who stirred herself to observe every changing nuance of fashionable Paris on behalf of an audience of English readers, "The Emperor's proclamation [of the departure of the imperial army to Italy] has been received with the greatest enthusiasm. . . . His speaking of leaving the Empress and the Prince Imperial to the charge of the people was certainly a most happy idea; for every Frenchman will now feel that Empress and Prince are confided to him personally, and will act accordingly."[119] The emperor, usually clever with such things, had another gimmick up his sleeve:

> [T]he Emperor, Empress, and Prince Imperial . . . visited the photographic establishment of Disderi & Co., before the departure of his Majesty for the seat of war. The result of this visit is, that all the windows of the fine print-shops are filled with photographs of their Majesties in every conceivable posture, both standing and sitting. The exceedingly low price of these objects, added to the fact of their being excellent likenesses, has caused them to have an extensive sale.[120]

If the imperial visit to Disderi *was* expressly undertaken on the eve of the emperor's departure for Italy, it was the equivalent of a final television appearance, guaranteeing that authentic images of the ruling family were placed in every French town large

Figure 34. CAMILLE SILVY. *Self-Portrait with Stable Lad(?), London Studio*, August 1859. Albumen print from wet collodion negative, 8.5 × 5.6 cm (3⅜ × 2³⁄₁₆ in.). London, National Portrait Gallery.

enough to boast a stationer. The new *carte de visite* photographs were everywhere.

Was Paris unbearably dull for Silvy, waiting for his papers of accreditation as photographer to the campaign? Presumably, many of his companions had gone to Italy as soldiers. However, by the time of their return, symbolized by eighty thousand troops marching into Paris with the emperor at their head on August 14, 1859, Silvy is unlikely to have been in Paris. He had moved to London, where he set himself up as a portrait photographer, having acquired one of the grandest studios, that of Caldesi and Montecchi, at 38 Porchester Terrace, Bayswater, looking onto Hyde Park. His first photograph made there is a *carte de visite* self-portrait with a young boy—possibly a stable boy—dated August 1859 (fig. 34).[121] Elizabeth Anne McCauley, the recent elucidator of Disderi, patentee and promoter of this type of portrait, has stated that the latter's "first thoughts were arithmetic rather than aesthetic: by dividing one collodion-coated glass plate into ten rectangles which could be exposed simultaneously or in se-

ries, ten portraits could be printed in the time that had formerly yielded a single, full-plate image."[122] The idea of mass production presupposed mass consumption, and indeed the new kind of portrait was sold by the score—to individuals who traded portraits with their friends—or by the thousand (and hundred thousand, and more) in the case of celebrities. Portraits of royalty were said to run into the millions.

It was a bold decision for a young Frenchman to set himself up in London as a portraitist using a new kind of mass production technique. It was also logical. In the 1850s France looked to England as the home of industrial imagination, of that technological prowess and progress made spectacular by the 1851 international exhibition, which was emulated in Paris in 1855, updated in London in 1862, and trumped again by Paris in 1867.[123] English political stability was allied to fiscal creativity, an up-to-date educational system, and interesting and impressive—to French observers—ideas about industrial art and design.

Silvy proceeded to establish a portrait photography factory in Porchester Terrace. The historian David Lee has suggested that he was very probably the first *carte de visite* photographer in London.[124] He was certainly among the most successful and the most talked about. Like the ruler who set the tone of the Second Empire, Silvy possessed a gift for publicity. It is at this moment in his life that he suddenly comes into clear view as a man—and businessman. Silvy was described by professional journalists, visited and later recalled in his autobiography by Nadar, and admired by London's presiding literary genius, Charles Dickens. We shall look at the photographer first through the eyes of a journalist who wrote an article on *cartes de visite* for *Once a Week*, an illustrated periodical of "literature, science, art and popular information," in January 1862, by which time Silvy's establishment was in full swing:

In walking through the different rooms, you are puzzled to know whether you are in a studio, or a house of business. His photographic rooms are full of choice works of art in endless number: for it is his aim to give as much variety as possible to the accessories in each picture in order to accomplish which he is continually changing even his large assortment. Sometimes when a Royal portrait has to be taken, the background is carefully composed beforehand, so as to give a local habitation, as it were, to the figure. The well-informed person, without a knowledge even of the originals, may make a shrewd guess

Figure 35. CAMILLE SILVY. *38 Porchester Terrace, Bayswater: Rear of Studio*, 1862. Albumen print from wet collodion-on-glass negative, 10.1 × 11 cm (3¹⁵⁄₁₆ × 4⁵⁄₁₆ in.). London, National Portrait Gallery.

at many of the personages in his book of Royal Portraits by the nature of the accessories about them. Thus, all the surroundings of the Duc de Montpensier's daughter are Spanish, whilst his son's African sojourn is indicated by the tropical scenery. As M. Silvy takes every negative with his own hand, the humble as well as the most exalted sitter is sure of the best artistic effect that his establishment can produce. This we feel certain is the great secret of M. Silvy's success, as the skill required in taking a good photograph cannot be deputed to a subordinate. But, as we have said, his studio is at the same time a counting house, a laboratory and a printing establishment. One room is found to be full of clerks keeping the books, for at the West End credit must be given; in another scores of employees are printing from the negative. A large building has been erected for the purpose in the back garden [fig. 35]. In a third room are all the chemicals for preparing the plates; and again in another we see a heap of crucibles glittering with silver. All the clippings of the photographs are here reduced by fire, and the silver upon them is thus recovered. One large apartment is appropriated to baths in which the cartes de visite are immersed, and a feminine clatter of tongues directs us to the room in which the portraits are finally corded and packed up. Every portrait taken is posted in a book and numbered consecutively. This portrait index contains upwards of 7000 cartes de visite, and a reference to any one of them gives the clues as to the whereabouts of the negative. Packed as these negatives are closely in boxes of 50, they fill a pretty large room. It is M. Silvy's custom to print fifty of each portrait, forty going to the possessor and ten remaining in

74

Figure 36. CAMILLE SILVY. *The Hon. Eleanor Stanley*, 1860. Albumen print from wet collodion-on-glass negative, 10.8×7.5 cm (4¼×2¹⁵⁄₁₆ in.). London, National Portrait Gallery, Silvy Albums, vol. 1, no. 1014.

stock, as a supply for friends. Sometimes individuals will have a couple of hundred impressions, the number varying, of course, according to the extent of the circle. The tact and aptitude of M. Silvy for portrait taking may be estimated when we inform our readers that he has taken from 40 to 50 a day with his own hand. The printing is, of course, purely mechanical, and is performed by subordinates, who have set afloat in the world 700,000 portraits from this studio alone.[125]

If Silvy had taken seven thousand portraits in less than two-and-a-half years, this was an impressive slice of "the upper ten thousand." His quality control was impressive, too. Silvy's *carte de visite* prints are fairly easily recognizable as his because of both the elegance of the compositions and the excellence of their physical condition. The printing was necessarily routine, but he ensured that a generous gold-toning bath gave the prints richness of tone and coloration plus long-term durability. Registers preserved in the National Portrait Gallery, London, contain some uncut *cartes*, such as the 1860 portrait of the Honorable Eleanor Stanley (fig. 36), which show how Silvy worked. North light illuminated the subject from the right. Other uncut *cartes* show

that mirrors positioned to the left of the sitter reflected light back to give soft and even modeling, and also how top lighting separated the figure from the slightly less well-lit backdrop. A choice of painted "flats" was available, plus a variety of three-dimensional accessories. Though the painted flats have not survived, they may have been executed with something of the skill of the *papiers peints* for which the Second Empire was notable.[126] Silvy may have painted these himself, though a painter was among the staff of forty he employed. This individual was responsible for delicate tasks like painting in such additions to negatives as a ring of flaming candles in the background of a funeral portrait, commissions that Silvy sometimes undertook for his clients.[127]

It will be clear to the reader that there was no great difference between Silvy the landscape photographer, inserting a "flat" of clouds behind a favorite river view, and Silvy the studio portraitist—or Silvy choreographing his models in the countryside and posing his sitters aptly in a studio. Enjoyment of artifice informed both branches of his art. In the background of his celebrated portrait of the opera singer Adelina Patti, Silvy presented a sheet of water and a sky painted with a dark, billowing cloud.[128] Pursuing previous interests, he also made instantaneous equestrian portraits that cleverly arrested the horse with a foreleg raised heroically and unblurred.[129] In a series of photographs taken at Orleans House in 1867, Silvy produced a courtly High Victorian version of his earlier landscape with figures. He had often photographed members of the exiled house of Orléans.[130] As a leading light of the Société Française de Bienfaisance, he photographed a glamorous "Fête Champêtre" held, to raise funds for this charitable body, on the grounds of Orleans House beside the Thames (fig. 37).

The photographer's scrapbook contains a page of illustrations that show the costume in which Silvy attended—as Mephisto—a ball given by the Pereire brothers. The Silvy who moved with ease and distinction in such circles was vividly remembered by Nadar, whose outstanding close-up account of him is quoted here at length. Nadar visited London—and Silvy—in 1863. The picture conveyed by his words is paralleled by a *carte de visite* family portrait made at Silvy's direction (fig. 38). The photograph shows, in addition to the Charles the Bold tapestries mentioned by Nadar, Alice Monnier (born 1839; Silvy's wife). Her father, Alexandre Monnier, a historian, and his wife were friendly—according to descendants—with a circle of poets and painters includ-

Figure 37. CAMILLE SILVY. *Fête Champêtre at Orleans House, London*, 1867. Albumen print from wet collodion-on-glass negative, 10.8×15.4 cm (4¼×6⅟₁₆ in.). Malibu, J. Paul Getty Museum 84.XO.607.10.

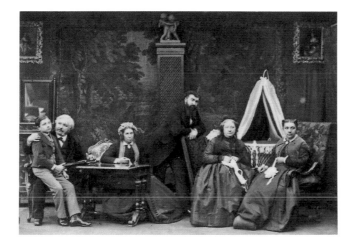

Figure 38. CAMILLE SILVY. *The Photographer and His Family, 38 Porchester Terrace, London*, circa 1866. Albumen print from wet collodion-on-glass negative, 5.6×8.5 cm (2³⁄₁₆×3⅜ in.). Paris, Monnier family.

ing Victor Hugo, Gustave Boulanger, Charles-Gabriel Gleyre, and Gustave Courbet. The splendid cradle suggests that the photograph was taken to celebrate the birth of the Silvys' first child, Jean. As Nadar put it in his somewhat florid text:

Silvy's personality comes to mind: Silvy, whose works and—to the same degree—personality, thrilled the London "Nobility"[131] and "Gentry"[132] for many years.

Certain people always seem to attract public attention, which continues to follow them, whatever they do or do not do. Fundamentally, Silvy was one of these people.

He was working in the diplomatic service and was assured of a brilliant career when, because of a sudden inspiration which was most unexpected but very understandable at that time, he dropped everything to establish a photographer's studio in London. Both the photographer and his house were quite unlike any others. . . .

Descended from a distinguished French family, Silvy revealed his Italian origins through his youthful, michaelangelesque features, the thoroughly academic correctness of his figure, and that classical purity of form which gives grace and rhythm to every gesture. Promenading in Hyde Park, which as a man of true elegance he was obliged to do with ritualistic punctiliousness, among the gentlemen and lady riders endlessly passing each other . . . through the Grecian arcades, this most accomplished *sportsman*,[133] riding a coveted thoroughbred, would have been noticed at once: the perfect, the final follower of fading dilettantism. Because of his striking originality, he could not have tolerated eccentric dress—only tasteful dress. This sensational figure could arouse the animated attention of crowds without seeming to notice a thing.

The looks—deep, long, and rapt—that lined the devastator's path! So many "Misses"[134] set a-dreaming, and such a worry for the mammas! He even had to call in the press once to refute some scandalous tales that . . . could have discredited him.

It was hardly surprising if the afternoons were never long enough to receive the aristocratic clientele who crowded to Silvy's door and kept returning again and again to make appointments weeks and months in advance, so that a lady should have the good fortune to find herself for a few minutes before the formally clad, white-tied charmer who—as each client entered the studio—would negligently cast a pair of white gloves into an already overflowing basket, and don another, irreproachably new pair. . . .

Moreover—and why should such a glory be a lesser one than others?—the following "Christmas"[135] one would be sure to find one's name printed in the Golden Book of the

year's clients which, as regularly as the *Almanach de Gotha*, the munificently courteous Silvy would send to his faithful clients.—What a thrill for the little world of the "Gentry!"[136] in this "Vanity Fair!"

Waiting, tenaciously resigned, in Silvy's *salons* could be lengthy but never boring. The establishment . . . was perfectly furnished and arranged. . . .[137] Clients could enjoy watching the streams of carriages and the aristocratic horsemen and -women who passed before the lens with barely a pause, or admire the decorative treasures that filled galleries appointed in the most elevated taste and the most lavish style. The choice and arrangement of the objects . . . gave the astounded English a glimpse of Latin genius.—I have to say, though, that the miraculous tapestry of Charles the Bold, woven in gold and silver, which I never tired of admiring, came from Flanders.

And yet Silvy made one concession to British foibles: THE QUEEN'S ROOM!—which was, exceptionally, fitted out in the purest English style.

Each visitor had to pass by this room. Its double doors were open, although a tall, beautiful gate of sixteenth-century Florentine wrought ironwork barred entrance to the profane. On the central mantelpiece stood an equestrian statuette in pure silver for which Silvy had paid thirty thousand francs, an impressive sum in those days, to Marochetti, a much favored sculptor of the time:—THE QUEEN!!! . . .—On seeing this, every true Englishman or -woman would bow the head in respectful silence, hardly daring to assuage with the merest side glance that terrible, I do not dare say brutish, requirement of objective curiosity which is one of their national characteristics.

No one was to enter this room—except the QUEEN, and no one did enter it: "Not even the Queen," said Silvy, laughing, "because I am still waiting for her. . . . But never mind: *It makes a good impression! . . .*"

In fact, he did make an enormous amount of money.—I think he knew how to spend it rather well too, as his air of the grand seigneur was not an empty affectation. He was born open-handed and with an open mind—and an open face, too.

Silvy remained an exceptional naturalistic artist during his first years in London. Some city photographs he made early in his stay are part of the frame within which we should view *River Scene, France.* A printed flier survives that shows that he intended to create a sequence of photographs on the theme of light and weather. This document is pasted into the press-cuttings book of the Photographic Society of Scotland on a page

Figure 39. CAMILLE SILVY. *Untitled Street Scene*, 1859–60(?). Albumen print from wet collodion-on-glass negative, 27 × 21.6 cm (10¾ × 8½ in.). Paris, André Jammes.

immediately following cuttings that relate to their exhibition held in the winter of 1858–59. Perhaps Silvy drew up this prospectus in the autumn of 1859. It offers a "Series on the Study of Light." The images were to be available with a new and short-lived publication, the *London Photographic Review*,[138] and the first picture was to be *Evening Star*. The flier explains that "yearly subscribers to the LONDON PHOTOGRAPHIC REVIEW will receive, as a Prize, two additional Photographs, which, with Part I, 'Evening Star,' will form one of the Series of the Studies on Light by C. Silvy." The other subjects are given as "BROUILLARD—SOLEIL—CREPUSCULE. FOG—SUN—TWILIGHT." André Jammes, Paris, owns a large and exquisite print signed by Silvy that could be either *Evening Star* or, more likely, *Twilight* (fig. 39). The Getty Museum possesses an equally astonishing tableau that takes up the notion of the "pifferari," a fertile

Figure 40. CAMILLE SILVY. *Les Petits Savoyards*(?), 1859–60(?). Albumen print from wet collodion-on-glass negative, 27.8 ×22.2 cm (11×8¾ in.). Malibu, J. Paul Getty Museum 85.XM.586.

theme in photography at this time (fig. 40). Street musicians were considered to be as typical of London's streets as fog.[139] The Getty tableau, which captures both elements, could perfectly well represent *Fog*. Like the Jammes picture, it was taken on the pavement outside 38 Porchester Terrace. Could Silvy have thought of representing "Soleil—Sun" in this series by *River Scene, France*? If so, he would have been obliged to find a way to print many copies of it economically. The print in the Château Saint-Jean was, it will be remembered, published by a London firm soon enough after Silvy's arrival for his premises to be styled "Late Caldesi and Montecchi." Possibly there is a connection between the publication of the print and the planned series on light. At the S.F.P.'s Salon in 1861, Silvy showed *Les Petits Savoyards*, *Le Premier Rayon de soleil*, and *L'Etoile du soir*. The Getty print of street musicians is likely to be identical with

Les Petits Savoyards, a photograph with two subjects—musicians and fog.

We can probably know nothing more of the relationship of Nadar and Silvy than Nadar himself set down. However, it is interesting to observe that there is some kinship between Nadar's conviction that photography was a quite extraordinary nineteenth-century invention, of uncanny dimensions and potentials, and Silvy's ardent beliefs about his medium. Rosalind Krauss recently illuminated the subtlety and depth of Nadar's late text on photography, emphasizing his sense of the medium as a *physical* imprint or trace.[140] Silvy too found evidence that photography is a direct transaction with physical properties, involving the recording of traces that might even be invisible to the human eye. He was, like many of his contemporaries, interested in reproducing works of art. In London, he began to produce a series of books of photographic reproductions of important early manuscripts. As a result of photographing the "Sforza Manuscript," he made a discovery that he described in an address to the Académie Impériale des Inscriptions et Belles-Lettres, Paris, in 1860. First, he found that, although it looked faded to the eye, ancient writing in black ink on parchment looked very different to a collodion negative and printed crisply. The copy was more legible than the original. Then, he realized that the last page of the Sforza Manuscript contained something invisible to the eye but distinct to the selectively color-blind collodion negative: an old, yellowed inscription in German, "between the portraits of Louis the Moor and Fiselfo his teacher," which had sunk into the parchment. Because it read yellow as black, because it saw differently from the eye, photography could do more than reproduce. It could, Silvy understood, restore. A photograph did more than reproduce an existing picture.[141]

Silvy took part in one major controversy during his years in London. The episode illuminates his view of photography. During the preparations for the 1862 International Exhibition there, it became clear to photographers that their medium was not to be exhibited in the Fine Arts section but with industrial machinery. There was bitter criticism of the commissioners' judgment. The S.F.P. and the Photographic Society of London lobbied for fine art status. A compromise was reached whereby photography was placed with Philosophical Instruments (as had mostly been the case in 1851). Silvy, a member of both societies, stood out in favor of the industrial classifi-

cation. Far from being dismayed, he wrote in the *Photographic Journal* that he had

demanded from the Commissioners the favour of having my productions exhibited in the special mechanical department. However interested I may be in seeing photographic productions (to which I have been long devoted) highly estimated, still I cannot hide from myself that the chief merit is produced by the wonderful means that science has placed in our hands; and since I am in a country renowned for its horses, allow me a comparison which, I think, develops my idea:—Would the constructors of locomotives be right to enter their engines for the Derby in order to compete with thoroughbred horses? Such an idea has never been thought of, and I consider that the genius of photography will suffer no disparagement in being placed amongst the most wonderful machines which this era has yet produced.

Silvy threatened resignation from the Photographic Society of London on the point. His stand drew a long riposte from another highly distinguished French portrait photographer practicing in London, Antoine Claudet, F.R.S., to which Silvy, completely unabashed, replied at length. Despite his own drastic interventions in the process of photographic illusion, Silvy stated that "Fine Arts create. Photography copies. The difference between the two is so clear, so evident, that it is unnecessary to dwell on the point." In the end, Silvy showed three prints in the French section—for the photographic displays were dotted all over the exhibition by country. His *Little Savoyards*, *Evening Star*, and *Emperor's Order of the Day* were described by *La Revue photographique* as "ravissants."[142]

Silvy was himself an inventor of astonishing machines. When war between France and Prussia began to loom in the middle 1860s, he devised a cylindrical camera body that could house a rolled waxed-paper negative. In 1867 he made a 360-degree panorama of the Champs Elysées to demonstrate the technique (fig. 41). This view of one of the centers of high bourgeois culture renders it not as metropolis but as terrain. Silvy also developed the idea of a tripod that would keep a lens perfectly horizontal to the ground for surveying purposes.[143] He was involved in an experiment for making long print runs of photographs in ink, he worked in photoceramics, and he photographed the royal tombs in the Dreux chapel in Normandy by magnesium light.[144]

Figure 41. CAMILLE SILVY. *Panorama of the Champs Elysées, Paris*, 1867. Four modern gelatin silver prints from continuous paper negative, each 12.7 × 23.8 cm (5 × 9⅜ in.). Paris, Société Française de Photographie.

Thomas Sutton, photographer, inventor, and journalist, gave this close-up view of Silvy, published in 1871:

> I have a pleasing recollection of my first introduction to this photographic genius. It was late on a fine afternoon in May; and, as I was strolling along the hot pavement towards the celebrated suburban studio a cab dashed past me, pulled up at the gate, and out jumped first a Newfoundland dog dripping with water, and then its tall, powerful, energetic young master, who had been having a bathe also after the last guinea portrait had been taken that day. I followed, and was most cordially received. In a minute we were the best of friends; and M. Silvy took me all over his premises, showed me everything. . . . He was then fitting up an immense battery for an electric light with which to take enlargements.[145]

Sutton may well have given Silvy the idea for the fifth state of *River Scene, France*, a *carte de visite*-size copy published by an unknown London company (fig. 42). Only two examples are at present known to survive. The idea of publishing Silvy's masterpiece in this democratic format could have originated in an article Sutton had published in 1863, "On Some of the Uses and Abuses of Photography":

> The most important and remunerative practical use to which photography has been put is that of taking miniature portraits of distinguished people, and selling them at a price

which puts them within reach of all . . . large views and large portraits have been a comparative failure. I believe this will always be the case . . . although It is not improbable that a fashion for cards of views may shortly spring up, and become a remunerative business; if that should ever happen, I advise photographers to multiply small negatives from a large positive print.[146]

Silvy also produced a sixth state: a slightly larger reproduction of *River Scene, France*, of which one unmounted copy is preserved in the Monnier family collection. It is about the size of that other standard format of the later nineteenth century, the "cabinet card" established in 1866: a print of 140 by 102 millimeters pasted on a card of 165 by 108 millimeters.

In 1862, Silvy offered the town councillors of his French birthplace a new and fully equipped laboratory for chemistry and physics—provided only that they set aside a room in the *mairie* and enroll suitable students. The authorities responded unenthusiastically, declaring that there was little industry in the district and that scientific instruction had small relevance. Silvy continued to press and cajole, writing of how he had—young and unknown—arrived in a foreign country, bringing little photographic and scientific equipment or money but nonetheless making a fortune that he wished to share.[147] The sciences, he wrote, had brought the great discoveries and innovations of the epoch, "like flashes of light which tear open dark clouds and enable us to glimpse immense illuminations beyond the limitations of our present modes of vision." Having failed with the laboratory, Silvy tried to despatch the *abbé* Moigno (Paris savant and

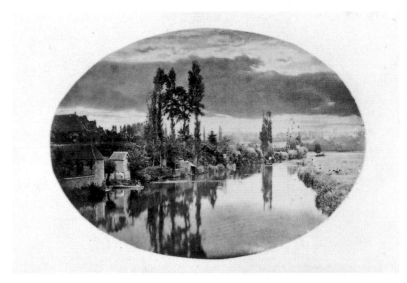

Figure 42. CAMILLE SILVY. *River Scene, France*, 1858 (State 5). Printed 1860s(?). Albumen print from wet collodion-on-glass negative, 5.7 × 8.2 cm (2¼ × 3¼ in.). Paris, Monnier family.

editor of *La Revue photographique*) to organize a conference on gas lighting and heating, which had recently been brought to Nogent, to educate people in the theory and practical benefits of the new technology. Nothing was done, and Silvy withdrew his offer.[148]

Silvy announced his last season of portraiture in the London *Times* on April 6, 1868. The *carte de visite* phenomenon had inevitably faded, and his business had dwindled.[149] He had habitually given La Croix-du-Perche as his address in France during the 1860s. In July 1868, he made his last portraits. He sold his business to the theater photographer Adolphe Beau[150] and returned to Gaillard.

Before following Silvy back to France and into his later life, there is one further appearance of *River Scene, France* in England to be noted. Charles Dickens wrote an admiring letter to Silvy in 1862 which the photographer copied and added to the company register.[151] The letter was prompted by a note of thanks from Silvy for an article that had appeared in Dicken's magazine *All the Year Round*, "The Carte de Visite" by W. H. Wills, who had sat to Silvy a year earlier.[152] The entertainingly written piece

contrasts the bad old days of portrait photography with the pleasures of an up-to-date studio (clearly based on Silvy's). Wills discusses the all-importance of lighting and the choice of a particularly favorable moment in capturing a true likeness:

> Even in nature, out of door nature, it is so. The view which you saw from the hills above
> the old French town, with the evening sun lighting up the rich plain, making the moun-
> tains in the distance amethysts, and the river a line of gold, while the one cloud shadow
> lay over the old cathedral tower and blackened it, so that all the rest sparkled the more—
> what is that very same scene when the sky is grey, and the mountains grey too, and plain
> and river and cathedral are all of one monotonous slate-colour![153]

Let us suggest that Wills misremembered *River Scene, France* and that Silvy had showed him a print of it when he had his portrait taken. Silvy used a variety of accessories to vary his compositions, one of which was a portfolio (with *C. Silvy* printed on a label on the outside) to hold or lean on. In at least thirty instances, he opened the portfolio and drew out a print that can be identified without difficulty as *River Scene, France*. Even though the landscape print occupies only a tiny patch in a *carte de visite*, it is clear that there is cloud detail in the water and that the print shown is one of the later states (fig. 43). It is nearly always women who are shown displaying the landscape. The picture continued to be known in London during Silvy's career as a portraitist and may have become a talisman for him.[154]

According to Silvy's curriculum vitae, in August 1868 he took up the post of *agent consulaire* (promoted to vice consul in May 1870) of the French government at Exeter, county town of Devon, in England's West Country—for no pay or known reason. Perhaps it was a humble stepping stone intended to lead to grander diplomatic postings. At present, we can only guess.[155] He returned to France when the Franco-Prussian War broke out, serving as a lieutenant in the Seventh Company of the Fourth Battalion of the *Garde-Mobile* of the Eure-et-Loir department. There was severe fighting all around Nogent. Afterward, Silvy published two (out of a projected series of five) pamphlets describing the campaign fought by his battalion. Following the dedication, "A mes compagnons d'armes et de captivité," Silvy explained how he had become a soldier. He related the history of his travels in Algeria, his unsuccessful role as

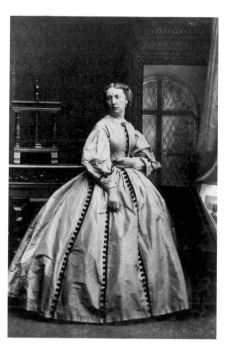

Figure 43. CAMILLE SILVY. *Miss E. Vyse*, May 14, 1862. Albumen print from wet collodion-on-glass negative, 8.5 × 5.6 cm (3⅜ × 2³⁄₁₆ in.). London, National Portrait Gallery.

war photographer in the Italian campaign, and his application of photography to the needs of war documentary by perfecting panoramic techniques in 1867. By the time of the 1870 catastrophe, he had realized that his country needed "soldiers not historiographers." He recalled that when the new government in Paris ordered "guerre à l'outrance" on September 24, 1870, his battalion had numbered about a thousand lightly armed men. They had fired at a target only once and had used no more than three rounds of ammunition. Silvy's pamphlets are eyewitness reports of appalling sights. Each day he recited lines from Hugo's *Les Châtiments*.[156] He was mentioned in dispatches (*Ordre du Jour*, November 19, 1870) and became *Chevalier de la Légion d'Honneur* on December 8 of the same year. He had saved the lives of two companies of fellow-soldiers encircled by the Prussians; he was wounded in the bombardment of Asnières. After his recovery, he planned to photograph the battle sites for publication in his history of the campaign.[157] However, although he listed photographs, lithographs, and

maps on the contents pages, no illustrations were ever published. Silvy's health had given way.[158]

Part of the mystery of *River Scene, France* is that it has so little history after 1858–59, except for some glimpses of it in Silvy's London studio. The taste for large exhibition photographs began to wane soon after his great success with it. Perhaps critics began to find its artifice obvious. A reviewer of the Photographic Society of Scotland's exhibition in the winter of 1859–60 wrote of the previous year's star:

M. Silvy, who, we believe, has now settled in London, has sent a considerable number of specimens, but, generally speaking, of a very different kind from his fine contribution of last year, "A French River". Even that performance, eminently clever as it was, was not without its drawbacks, for the extreme darkness of the sky was not in harmony with the tone of the rest of the landscape, and it was easy to perceive that the sky and the body of the landscape had been printed from two different negatives. This year he sends but one landscape, "La Mare aux Cygnes", The Swans' Pool (No. 393 [presumably *The Pond at Gaillard*]), and it is in every respect inferior. But in return he contributes some very clever little scenes which he calls "Cartes de Visites"—en plein air, à l'interieur, et équestres, and one admirable "Portrait of a Lady" (No. 916), which, for grace of pose and agreeable treatment, cannot be surpassed.[159]

However, there is another reason for the truncated history of this famous picture. Silvy's own history came prematurely to an end. Like an unknown number of other workers in photography in the nineteenth century, he was poisoned by the cyanide of potassium he used to fix collodion negatives. Ernest Lacan published an article on illnesses caused by dangerous materials used in photography in his journal *Le Moniteur de la photographie* in 1874. The article was written by Dr. Napias, the medical adviser of the Société de Secours Mutuel des Employés en Photographie, Paris. "Doors opened to the absorption of cyanide," Napias wrote, "are doors opened to death."[160] The essay elicited a letter from Silvy, who recounted how he had used the chemical in large quantities over many years. He remembered exactly how he had inadvertently ingested it. Without having completely rid his hands of it after working in the darkroom, he had taken a piece of fruit from a dish and eaten it. After giving up professional photography in 1868, he wrote, he was still under medical care six years later. A second letter mentioned that

the illness had given him a horror of collodion and that he would only now use the waxed-paper process.[161] Could State 3 date from this period and be a print from a waxed-paper copy negative of *River Scene, France?*

Cyanide of potassium attacks the central nervous system. Perhaps the illness was seriously aggravated by the wound Silvy suffered in the Prussian war—but confusion descends on later reports of him. A newspaper published—on the same day as its page of obsequies for Victor Hugo, in May 1885—a story that Silvy's London business had ended in financial ruin and that this had affected his reason. The same report suggests, alternatively, that he had gone mad because of a severe fall from a horse.[162] Perhaps he never returned to Exeter after the war.[163] When he wrote to Lacan in 1874 about the death, probably from chemical poisoning, of Thomas Sutton, Silvy was perfectly lucid, but he wrote from a *maison de santé*.[164] No other activities are recorded. In 1881, Silvy was made the ward of his father and his wife and committed to an asylum at Saint-Maurice (Seine).[165] He died there on February 2, 1910,[166] and was buried in the Père Lachaise cemetery in Paris. The gravestone gives his name as Camille-Léon-Louis Silvy de Piccolomini.[167]

Reflections

L'UNIVERS ILLUSTRE, A PARIS PICTORIAL MAGAZINE, inaugurated a new feature on January 1, 1859: a series of "chants et chansons populaires de la France." The first song was "Madame Fontaine" by Fernand Desnoyer. "Madame Fontaine" is not only a fountain but a river nymph, a muse, a nature spirit, the genius of French landscape, inspiration; its writer plays with ideas about mirrors, reflections, and doubling. The song concludes with a scene composed of God-given sun, air, and water which is also a luminous picture, wide enough to fill the sight.

Silvy's *River Scene, France* is the same gentle, generic picture and place as that inhabited by the gracious Madame Fontaine, that late eighteenth-century creation for which Jean-Jacques Rousseau was the principal apologist. New editions of Rousseau's works were published in Paris in 1856–57 (twelve volumes) and again in 1856–58 (eight volumes), including *Reveries du promeneur solitaire*. The great illumination of *Reveries* takes place by water, on the island of Saint-Pierre in the middle of the Bieler See in Switzerland. Rousseau's reveries—drifting in a boat, sitting by the lake, or "on the banks of a lovely river or a stream murmuring over the stones"—licensed generations of dreamers.

Many of the dreamers were English, and one of them was William Wordsworth. C. H. Townshend owned a twenty-volume Rousseau, was also, in his youth, a disciple of Wordsworth, and went on writing wordsworthian verse into the 1850s. Townshend collected books like *The Sunbeam* (1859), an anthology in which snatches of prose and poetry face photographs chosen by Philip H. Delamotte. *The Sunbeam* contains photographs of rivers and reflections, and poetic reflections on reflections. The linked photographs and quotations make the book seem like an apologia for photography as a natural poetics—spontaneous, reflexive, directly imprinted by nature.

Townshend also owned *Our English Lakes, Mountains and Waterfalls as Seen by William Wordsworth*, photographically illustrated by Thomas Ogle (1864). One of the extracts of poetry, from *The Excursion*, Book 9, is titled "Image in the Stream." Com-

panions walking beside a stream halt at a bridge and gaze entranced at a white ram and its perfect mirror image:

> . . . Most beautiful,
> On the green turf, with his imperial front
> Shaggy and bold, and wreathed horns superb,
> The breathing creature stood; as beautiful
> Beneath him, showed his shadowy counterpart.
> Each had his glowing mountains, each his sky,
> And each seemed centre of his own fair world:
> Antipodes unconscious of each other,
> Yet, in partition, with their several spheres,
> Blended in perfect stillness, to our sight!

This is more than an anecdote, of course: the image in the stream is also an image of Wordsworth's central conviction that humanity's relationship with nature should be pure, clear, accurate, untrammeled.

The river/reflection photographs in *The Sunbeam* were prototypes of the images made for sale to tourists or holidaymakers for their albums in the 1860s and of photographic postcards a generation later.[168] *River Scene, France* was made at a moment between the development of certain highly photographic practices in European painting (particularly of the Danish and German schools) and the industrial production of the same kind of imagery by photographers. Apart from the ardent philosophical and poetic celebration of water, rivers, and reflections, there was—let us say—a propensity for such imagery within the procedures of photography, within the camera itself. Many photographers were fascinated by the forms of water reflections in the 1850s. In England in 1852, the calotypist Benjamin Brecknell Turner photographed Hawkhurst Church and its reflection as if formulating a syllogism. The picture, called *A Photographic Truth* (fig. 44), was much exhibited in the 1850s. Introducing the first exhibition of photographs held in England in 1852, in which *A Photographic Truth* was first shown, Roger Fenton referred to a number of classic English subjects, including "the still lake, so still that you must drop a stone into its surface before you can tell which

92

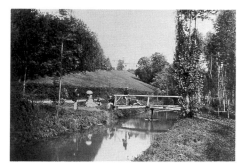

Figure 44. BENJAMIN BRECKNELL TURNER (British, 1815–1894). *A Photographic Truth (Hawkhurst Church)*, 1852. Albumen print from calotype negative, 26.1 × 36 cm (10¼ × 14³⁄₁₆ in.). London, Victoria and Albert Museum.

Figure 45. EDOUARD-DENIS BALDUS (French, 1815–1882). *Group in a Park*, circa 1853. Albumen print(?) from waxed-paper negative. Private collection.

is the real village on its margin and which the reflection."[169] It was perhaps in the following summer that the Frenchman Edouard-Denis Baldus made the photograph *Group in a Park* (fig. 45). (Is it a park? Or a country lane adjoining private grounds and a mansion?) Eugenia Parry Janis has pointed out, à propos of this photograph, that the best way to understand how a nineteenth-century photographer really viewed a subject is, first of all, to turn the image upside down. The Baldus is an agreeable, picturesque, natural scene. Turned through 180 degrees, the abstraction of the composition is dramatic—"a lesson in photographic composition."[170] Baldus interlocked triangles. The masses of dark conifers at the left and light poplars at the right contrast and balance. The figures assert a horizontal band; their reflections echo the distant houses. There is more to the picture, however: the very act of scrutinizing the world upside down on the ground glass gave a greater weight to reflections and alerted photographers to the pleasures of interpreting wraithlike impressions on the water.

However, the view on the ground glass offered something else: the chaos of overabundant data. On a large ground glass such as Silvy, Turner, Baldus, and their river-loving contemporaries used, the predominant visual impression is exorbitant in-

formation. Relief from the surfeit of scarcely differentiated fact offered by "nature" was afforded by such elements as massive buildings, wide rivers, and broad skies. Clearly separated tree forms could obviously be of some use in making a scene intelligible. The problems of composing on a large camera were still relatively new to Silvy in the summer of 1858. He *may* have used a large camera in Algeria in 1857. He could equally have begun, like Turner, with a smaller one. Also, a more important point, in Algeria he was evidently photographing buildings, which do not usually demand, although they may inspire, the same compositional ingenuity as landscape. Silvy's *River Scene, France* is a brimming inventory of visual phenomena, elegantly articulated by the use of major compositional devices of the kind just mentioned. For him and his contemporaries, a river or a band of sky offered (compositionally) the solidity of granite. Rivers incessantly attracted many of the early photographers, with their very large cameras, and the reasons were not only philosophical but practical.

Is there a plausible connection between impressions in water in photographs from the 1850s and Impressionist painting? In a revisionist article, Kirk Varnedoe forcefully argues against the idea that photography significantly influenced the development of the latter. He places the question in a larger context:

> One lineage to which the origins of Impressionism can be assimilated became visible as early as Constable's cloud studies. Consonant with the progress of physical science, but not based upon it, this inquiry demanded ever more precise empirical specificity and concentrated more and more exclusively on contingent data rather than the permanent ideal. Progressively eliminating inherited conventions of depiction, it analytically divided time and fact into fragments, independent of allegorical, metaphysical or even standard narrative binding force. This progress led later realist artists (Flaubert and Zola as well as Monet and Degas) to seek out, embrace and develop as devices of artistic communication certain modern sub-structures of representation—instantaneity, synecdoche, disjunctive raw factual inventory, etc.—that we may now think of as photography's essential tools. Photographers of the day, however, were not involved in this line of inquiry. If they propagated such structures of representation at all, they did so meagrely, involuntarily, more or less covertly, in the course of accepting the unwelcome consequences of the limitations of their medium.[171]

This is well and convincingly stated. However, does it answer when we look specifically at Silvy's *River Scene, France*?

Take first the question of "instantaneity." It was suggested earlier that Silvy very probably acquired a Voigtlander Orthoscopic lens because of its combination of clarity and speed. Instantaneity is inscribed throughout *River Scene, France*, sometimes in paradoxical ways. Thus, the water is mirror-calm, the foliage is—apart from the tallest treetops—unruffled, the contours of the arrested clouds are distinct, the people are motionless and sharply rendered, etc. The slight blur of the boy's raised arm and the intriguing swirls and streaks that mark the passage of the waterfowl flourish the instantaneity of the piece even more decisively. We have seen that Silvy used this kind of blur elsewhere, and more dramatically, in his London street scene (fig. 40). "Disjunctive raw factual inventory"? That is abundant in the street scene just mentioned. There is nothing raw or disjunctive about Silvy's *River Scene, France*, apart from the awkward fit of sky and landscape. However, *inventory* is precisely the word for its intensely descriptive character.

Before anyone says "All photographs are inventories!" let us take stock of exactly what is being inventoried in this picture. The eye drifts, as if we are in a skiff, along an edge: a riverbank which is also the end of the gardens of houses which are also at the edge of a town. This edge is full of incident, and surely the photograph was composed so that a spectator's gaze would travel, leisured and weightless, along its variegated diagonal, to a vanishing point on the horizon, returning along the other bank, and so beginning again.

At the beginning, at the left, there is a walled garden inside which I believe I see a vine. Reeds grow vigorously along the base of the wall, their roots in the river. But what is this long, low building with a pitched roof, a door on the near side, and a ventilation hole in the roof? Perhaps it was used for work to do with barges transporting material to and from the mills. See how the opposite bank has been kept trim to allow river craft maximum leeway. The local authorities ordered that the riverbanks be cleaned up every August.[172] A street plan of 1864 suggests that there was a pathway through to the river from rue des Tanneurs, coming out where the young woman is standing on the lopsided plank jetty. The pollarded willow beside her inclines toward

the young man, above whose head is a spray of hazel. Photography excels at such circumstantial metaphors and analogies, achieved deftly and sometimes unconsciously. Between the couple there is a small outbuilding, perhaps a washhouse, on a square plan, with the pantiles and ridge tiles typical of this part of France. The base is masonry, suggesting that perhaps there was an earlier structure here. The ridge tiles and the lime mortar between them look very new. The punt would sometimes have been moored to the two poles in the water, but perhaps it was kept in the boathouse farther downstream. Other outbuildings can be glimpsed among the foliage, pale, flat surfaces of walls among the leaf and twig shapes. The trellises are of a type still used here. There are several openings from gardens to the river. Unlike the ground near the jetty, these paths are clearly marked but not trodden down. These are domestic spaces. The boat house—its roof warped out of true—has a ladder inside. Perhaps there are fruit trees in that garden, beneath the lombardy poplars. The grand houses to the left are in fact one building, which shows one facade to the rue des Tanneurs but projects two wings side by side toward the river. It is a vernacular, not an architect's, town house built, perhaps, for two related families around 1800.[173]

All along the bank, there are little bits of fencing and jetties. A long curved pole—probably a hazel bough—reaches down from a garden, beside another strip of trellis, to the water. Perhaps it helped to mark off one garden, fairly informally, from its neighbor. Or was it part of a child's game—the end not of a garden but of an Empire? Other bits of buildings peep from the foliage. To the left of the smaller pair of poplars is a good-sized house with more trellising, tall chimneys, and a barn. To the right of the poplars is the answering rectangle of a field. Then other fields, distant woods, and, finally, more poplars in a line. They resemble the schematic ranks of poplars which cartoonists of the day drew as shorthand for landscape—or landscape in an amateur's painting.

No one could be sure of making out all the details on this riverbank, which has so many signs of human settlement. However, no one could look at the picture without dwelling on the informal jumble of shapes and tones and trying to make some scraps of sense from it.

The point is not merely that it is a copious inventory. T. J. Clark has sharpened

our sense of the iconography of edges:

> Whether one looks at the painters of Rome and its *campagna*, or the English in the eighteenth century, or Auvers and Barbizon, it is always the difficult, provisional relation of man to nature—the extent to which man makes the landscape or is made by it—that is the main motif. It is the stuff of landscape painting, this progress from barren waste to broken column to rude cot to decent farm to thriving village to nestling town with determinate edge; or from commons to enclosure or rapids to sluice. . . . What forms of *visibility* were provided as part of this overall process of control and understanding? How was the countryside kept at a distance, brought into view, produced as a single human thing, a prospect or a panorama?[174]

In picture after picture from the 1870s, the subject is the edge of town. Leaving aside the characteristic Argenteuil mixture of signs of industry and recreation side by side, Impressionist painters discovered a pressing need to render houses glimpsed among trees at the edge of town. These mixings of nature and human nature are characteristic of Dutch landscape painting of the seventeenth century, which had been the subject of intensely appreciative critical scrutiny in France and Britain for much of the first half of the nineteenth century. The painting of religious subjects and history receded, giving way to landscapes with a quotidian, human dimension. This great, but greatly prepared for, shift of the midcentury expressed a new spiritual condition.

Silvy's river exercises, like those of Daubigny, a powerful suction into the picture, and his figures are doing something significant by doing nothing. They are, in the words of Thorstein Veblen, "performing" or "rendering" leisure.[175] They are, that is to say, like the woman in white and gray who stands on the left bank of the wide river in Monet's *Landscape near Zaandam* of 1872 (fig. 46). She waits beside the boats, almost lost in willow leaves and reflections. Around her are idiosyncratic buildings of the sort rivers encourage—buildings made to capitalize on the view. Roughly where the lower poplars appear in Silvy's photograph, Monet has placed the sail of a boat. Open water, a built-up left bank, a river racing to the horizon, a possibly less kempt right bank are all common features. The astonishing bravura of Monet's technique owes nothing to photography, I will agree with Kirk Varnedoe. Monet improvised an as-

Figure 46. CLAUDE MONET (French, 1840–1926). *Landscape near Zaandam*, 1872. Oil on canvas, 43.7 × 67.3 cm (17¼ × 26½ in.). New York, Metropolitan Museum of Art.

tonishing dance among the ripples. Silvy's reflections have the attraction of that moment in dance which is perfect poise. However, in composition and iconography *River Scene, France* is a remarkable anticipation of the Monet of 1872. Here is a case in which photography, perhaps drawing upon the conventions of magazine and topographical illustration and the most progressive paintings of the Salon (Daubigny) *and* working with its own specific properties and constraints, suggested a direction that important French painting was later to take.

Or was the development of Impressionism independent? Could the structural similarities between the photograph and the 1872 painting be explained by the adherence of both Silvy and Monet to the stock of immemorial pictorial devices available to both in the Louvre? Both would have known, for example, Claude Lorrain's little

oval *Pastoral Landscape* on copper (1630–35),[176] and both were composing modern idylls—but there are hundreds of kindred paintings. Perhaps Claude's italianate lighting is reflected in Silvy's photograph—but the composition was also a favorite of the seventeenth-century Dutch masters. When one of Silvy's earliest critics compared *River Scene, France* to a landscape by Aert van der Neer, it was an extremely accurate attribution of the prototype. C. H. Townshend owned another variation of the idea, by Salomon van Ruysdael, in which the ingredients are laid out minimally, with a wide but shallow foreground and a vanishing point at the extreme left.[177] The use of this Dutch pictorial model by Silvy was probably recognized by Townshend as well as by the Edinburgh critic already mentioned, by Ernest Lacan in his subtle appreciation, and by many exhibition-goers of 1858–59. Later viewers of the photograph probably recognize the structure too, if not always consciously.[178]

The iconography of edges can be approached from another direction. Seventeenth-century paintings, especially those of Claude and Meindert Hobbema, provided the geographer Jay Appleton with some of the most telling illustrations of his "habitat theory." This theory, frequently cited in discussions of aesthetics by landscape architects, geographers, and planners,[179] provides another way of analyzing Silvy's photograph. Appleton advanced the notion that looking at landscape pictures is informed by "spontaneous perception of landscape features which, in their shapes, colours, spatial arrangements and other visible attributes, act as sign-stimuli indicative of environmental conditions favourable to survival."[180] Chief among these requirements are the two needs of the hunter. A hunter advances to the edge of a wood and reconnoiters from cover. He must see without being seen. Appleton developed a theory of landscape which revolves around "refuge" and "prospect." Clearly, the banks of the river Huisne in 1858 offered excellent possibilities for refuge together with a prospect that seems panoramic. The theory becomes interestingly complicated when it is mixed with a reading of the social class of the figures in Silvy's picture: the bourgeois couple in the safety of the refuge on the left bank contrasted with the common people in the unsheltered prospect.

Paintings provided an important part of the inspiration and composition of Silvy's photograph, but it is a production of the astonishing period of industrial ex-

pansion in the 1850s which created the modern world. *River Scene, France* is deeply characteristic of this long moment in the formation of the age of capital. The photograph is a Positivist landscape of the Second Empire, filled with the light of faith in the new technologies that seemed to harness nature's forces for human ends. It is a machine-made, sun-printed, optically hard-edged landscape of progress. We can find analogical landscapes in the pages of *Le Magasin pittoresque*, which proclaimed a shining path of progress. In 1858–59 *Le Magasin* ran a series showing old and new farming methods. Peasants reaping with swop-hooks appear on one page; a horse-drawn mower from Burgess and Key whisks across the facing page. Hand-threshing, with swiveling, jointed poles—a scene from Millet—confronts the steam-driven alternative, which impressively belches smoke.[181]

Modernity is evident in the high technical accomplishment of Silvy's photograph, but it is also present in detail. I have referred to the field to the right of the smaller poplars in the middle distance. A colleague who both is a historian of photography and has an unusually keen eye for what is produced in the landscape was able to make out, with his naked eye, crops of some kind lying in the field.[182] Botanists at the Natural History Museum, London, were able to identify the crop as hay, lying in regular lines because it had been cut mechanically rather than scythed. They were also able to suggest, undogmatically, that the photograph probably was taken in July, given the general state of the foliage, including such details as the height of the thistles or docks in the meadow.[183]

The 1850s landscape of new technologies appears in a slightly different but revealing guise in Gustave Flaubert's *Madame Bovary*. The descriptive temper of the narrative is hardly less photographic than Silvy's *River Scene, France*. Flaubert's novel, published notoriously and triumphantly in Paris in 1857, also concerns itself with edges, details, mixings of the natural and the man-made:

In summer there was more of its shelving bank to be seen, and the garden walls were uncovered to their bases. . . . The river ran noiselessly, swift, cool to the eye. Tall slender grasses leaned above it in a mass . . . weeds streamed out in the limpid water like green wigs tossed away. . . . The sunshine darted its rays through the little blue bubbles on the wavelets that kept forming and breaking; old lopped willow-trees gazed at their own

grey bark in the water. Beyond, the fields looked empty for miles around.[184]

Flaubert has poplars growing by the river that runs past the trellises and arbors of Madame Bovary's garden. The same trees punctuate the steamboat journey up the Seine that opens *A Sentimental Education* (1874): "[A]t every bend in the river the same screen of pale poplars could be seen." Writing recently on Monet's series paintings of the 1890s, Paul Hayes Tucker argued persuasively that poplars possessed a special meaning as symbols of *la Patrie*. He also suggested that they resonated with specifically Republican symbolism. "Liberty Trees" were planted in honor of the revolutions of 1789 and 1848, and poplars were often—if not exclusively—chosen.[185] So, was the early critic right in suspecting that *River Scene, France* was a patriotic, Republican image composed in defiance of the usurping emperor? Liberty Trees were planted (as indeed occurred at Nogent in 1848) in the main squares of towns, not just anywhere. The context makes them Liberty Trees, not the species. It is surely unlikely that the photographer to the crowned heads of Europe, and the recently uncrowned ones of the house of Orléans, was a Republican. The lombardy poplars—*peupliers d'Italie*—no more represent the Republic in this photograph than they are a secret sign of the photographer's ancestry. However, perhaps the patriot who made the photograph recognized the immemorial appropriateness of water-loving trees to this setting and accepted their typicality, their Frenchness.

I have tried to look at Silvy's photograph in detail because that is in the spirit of the photograph itself and of the time to which it belongs. Why did photography have to become so incredibly cumbersome in the 1850s and produce such overwhelming evidence of the world? We may be sure that C. H. Townshend, whose workroom contained an array of magnifying glasses, looked minutely at photographs. Here is the photographer Francis Frith writing in 1859:

Every stone, every little perfection or dilapidation, the most minute detail which, in an ordinary drawing, would merit no special attention, becomes, in a photograph, worthy of careful study. Very commonly, indeed, we have observed that these faithful pictures have conveyed to ourselves more copious and correct ideas of detail than the inspection of the subjects themselves had supplied, for there appears to be a greater aptitude in the

mind for careful and minute study from paper . . . than when the mind is occupied with the general impressions suggested by a view of the objects themselves.[186]

But why make such an absorbed inspection of the world rendered on paper? Carlo Ginzburg's essay "Clues and Scientific Method" is extremely helpful here. Ginzburg explores the role of the clue in three distinct practices in the late nineteenth century: first, in the art connoisseurship of Giovanni Morelli, who paid special attention to ears and hands in old master paintings as clues to authorship; second, in the criminal detection of Arthur Conan Doyle's Sherlock Holmes, who lights on telling details to make crucial deductions; and third, in the psychoanalytical method of Sigmund Freud, which makes diagnoses from "marginal" or "irrelevant" symptoms. This "conjectural or semiotic paradigm," as Ginzburg terms it, became a method in the new social sciences formulated to address the ever-increasing complexity in social structures of advanced capitalism.[187] To take one of Silvy's early admirers, Townshend was hardly remote from these strands—for example, the fascination with detectives used with such success in their books by his friends Dickens and Wilkie Collins.[188] Townshend's circle was also deeply immersed in Mesmerism, which is part of the ancestry of psychoanalysis. Townshend himself was also a connoisseur of some stature. If we look at Silvy's photograph for clues of many different kinds, we shall not be far away from the intentness with which this photograph was examined in its own time.

However, in other ways we are remote from it. The painting on the easel at the center of Gustave Courbet's controversial painting *The Studio* (1855; Paris, Musée d'Orsay) is a river scene from the artist's native landscape. A river scene is among the most scandalous paintings of the century—Manet's *Déjeuner sur l'herbe* (1863; Paris, Musée d'Orsay)—in which two men in modern black clothes share conversation and a picnic with a naked woman, while a second partially clad female bathes in the nearby river. The new river landscapes of leisure and industry, and of a new social class, dominate the painting of the 1870s. T. J. Clark has interestingly suggested that the awkwardly immobile pose of the man and woman sitting to Manet in *Argenteuil, les canotiers* (1874; Tournai, Musée des Beaux-Arts) is reminiscent of photographs.[189] Thanks to the photographic businesses set up at the end of the 1850s and after, members of all social

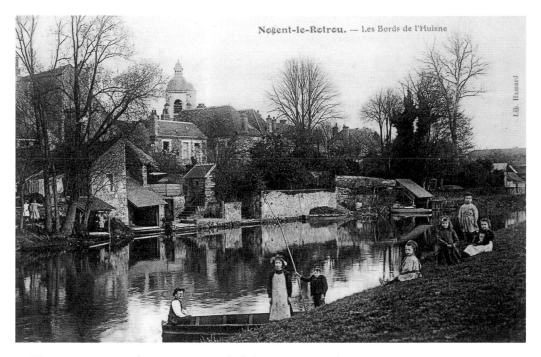

Figure 47. *Nogent-le-Rotrou: Les Bords de l'Huisne*, circa 1900. Photomechanical print, 8.9 × 13.7 cm (3½ × 5⁷⁄₁₆ in.). Nogent-le-Rotrou, Collection Musée Municipal du Château Saint-Jean 1964.19. Photo: Pascal Barrier.

classes in France could commission their own portraits for the first time in history. Perhaps Seurat's river scenes *Une Baignade à Asnières* (1883–84; London, National Gallery) and *Sunday Afternoon on the Island of La Grande Jatte* (1884–86; Art Institute of Chicago) are even more deeply marked by the arresting arrestedness of the photographic pose? Seurat might have conceived his statuesque riverside figures in the spirit of the *Pan-Athenaic Frieze* of Phidias,[190] but his people also belong in a world transformed by photographic events. They look on speaking terms with the Nogent children, and lone adult, who posed beside the Huisne for a postcard photographer around 1900 (fig. 47). The "card landscape" recommended by Thomas Sutton and tried by Silvy was an anticipation of the real popular success of the photographic postcard, which linked pho-

togravure printing (a technique based on W. H. Fox Talbot's photoglyphic process) to the postal service. In the card of the Huisne, the river has changed, and the *staffage* of previous art forms has moved into close-up. The people in the picture bought this kind of picture.

T. J. Clark has also argued that the sequence of French leisure pictures changed decisively with Neo-Impressionism, then shifted into myth with Fauvism.[191] Surely, the subject began to flourish in 1930s plein air cinematography.[192] This occurred, famously, in Jean Renoir's film *Une Partie de campagne* (1936–37). One of the assistant directors on the film was Henri Cartier-Bresson, whose career as a photojournalist includes river scenes of enduring appeal. The river scenes of Renoir and Cartier-Bresson became widely known and influential after the Second World War, but the motif was radically revised by Jean-Luc Godard in the film *Pierrot le fou* in 1965. The beginning of this film, a cocktail party at which fully clothed men exchange conversation (consisting entirely of advertising copy) with bare-chested women, is a hiatus indebted to Manet. Later in the film, Ferdinand and Marianne begin their picaresque flight through France, from and into crime. Ferdinand begins to read out of his journal. Marianne joins in. As they speak, they walk along the bank of a river:

FERDINAND *off*: Chapter Eight.

MARIANNE *off*: A season in hell.

FERDINAND *off*: Chapter Eight.

MARIANNE *off*: We crossed France . . .

FERDINAND *off*: . . . like spirits . . .

MARIANNE *off*: . . . through a mirror . . .

And then they leave the riverbank and walk into the water. They walk down the middle of the river toward the camera. They are pleased with this adventure, but the river gets deeper and deeper, and they move toward the bank and get out. They are sitting beneath trees in a glade in the Loire valley.[193]

By walking into the river, Ferdinand and Marianne abolish a number of different kinds of distance—between the object and its reflection, between the spectator and the view, between the actor and the camera, between the narrative of the film and

Figure 48. STEPHEN SHORE (American, b. 1947). *The Banks of the River Huisne, Nogent-le-Rotrou*, 1990. C-type color photograph, 20×25.3 cm (7⅞×10 in.). Courtesy of the artist.

the narrative of the journal, between the film convention and the film audience. Instead of standing reflected in the water, as if in a mirror, Ferdinand and Marianne break all these surfaces, stroll casually *through* the mirror. This is not a dramatic moment in the film, but it was surely not an idle gesture. Godard was not merely sabotaging the cliché of the French river scene; he was changing the codes of his art and its reception.

The American photographer Stephen Shore visited Nogent-le-Rotrou at the end of July and beginning of August 1990. He photographed from the latest bridge

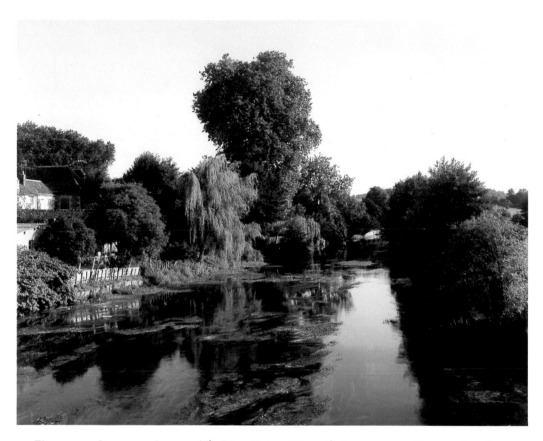

Figure 49. STEPHEN SHORE. *The River Huisne, Nogent-le-Rotrou*, 1990. C-type color photograph, 19.7 × 24.7 cm (7¾ × 9¾ in.). Courtesy of the artist.

over the Huisne (the former bridge was mined by retreating German troops in 1944) to give a contemporary view of Silvy's motif. He was able to photograph inside the gardens on the left bank and from the public land on the right (figs. 48, 49). This group of images indicates that the vista down the river had less to offer Shore than the signs of life of the inhabitants of the houses in the rue des Tanneurs. He also shows us the Brutalist lines of the Lycée Rémy Belleu, named after the town's famous poet, built at the edge of the old meadow. Downstream by the bend on the right, he photographed

the allotment gardens. Near the bridge, on the right bank, a woman supervises a paddling child and dog. Shore's camera picks up doublings and contrasts: the canoe and its reflection; vermilion paint and scarlet geraniums; the barren garden border and the ears of corn along a tablecloth; old ridge tiles and new coping; the way these are echoed by foliage creeping along walls and down gables; hand-done fretwork and extruded plastic; tennis balls and skateboards; an old shrub succumbing to the ferocious heat of 1990 (which brought the Paris railway lines to a halt); a new pump snaking to the river, back extensions, picnic tables, garden sheds, a foam rectangle floating upside down in the river.[194]

I think that we believe what the photographs by Silvy, the anonymous postcard photographer of 1900, and Stephen Shore tell us about this river scene in France. Like Silvy's first audience, we still accept the mirror-image as a symbol of tranquility, the fitness of things, peace—which is why Michael Cimino shows us, just for a moment, the perfect reflection of mountains in a lake immediately before the battle scenes that close his film epic *Heaven's Gate* (1980). However, we also circumscribe a photograph with doubt. We know that nature is not a mirror and that illusions are not obedient. The Polish émigré Czeslaw Milosz wrote a prose-poem called *Esse* at Brie-Comte-Robert in 1954. Milosz was concerned with the mystery of vision, the illusion that perception is possession, the appetite of sight, and a young woman opposite him on the Paris Metro. *Esse* curls an elegant philosophical question mark around the phenomena of being and vision: "She got out at Raspail. I was left behind with the immensity of existing things. A sponge, suffering because it cannot saturate itself; a river, suffering because reflections of clouds and trees are not clouds and trees."[195]

NOTES

Unless otherwise noted, all translations from French are the author's.

1. The press cuttings of this exhibition (and others arranged by the Photographic Society of Scotland) are in the Scottish Record Office, Edinburgh, ref. no. GD 356/4, ff29r–41r.

2. "The First Exhibition of the Photographic Society of Scotland," *Photographic Notes*, January 15, 1857, p. 25.

3. *Edinburgh Evening Courant*, December 21, 1858.

4. December 18, 1858.

5. *Photographic Journal* [*Liverpool and Manchester Photographic Journal*], January 15, 1859, p. 23.

6. Lady Eastlake, "Photography" (unsigned article), *Quarterly Review* 101 (1857), p. 444. Lady Matheson, Mrs. Horatio Ross, Miss Wilson, and Miss Ann Taylor, a professional, exhibited at Edinburgh in 1858.

7. Talbot is mentioned in the *Edinburgh Evening Courant* for December 18, 1858; his wife and daughter only are mentioned in the *Daily Express* and *Daily Scotsman* for the same date.

8. Lady Eastlake (note 6), p. 458.

9. Ibid., p. 460.

10. Ibid., p. 462.

11. Ibid., p. 465.

12. Ibid., pp. 465–66.

13. *Daily Express*, December 18, 1858.

14. See S. Stevenson, *David Octavius Hill and Robert Adamson: Catalogue of Their Calotypes Taken between 1843 and 1847 in the Collection of the Scottish National Portrait Gallery* (Edinburgh, 1981), p. 69, for two portraits of Hay.

15. I. Gow and T. Clifford, *The National Gallery of Scotland: An Architectural and Decorative History* (Edinburgh, n.d.), p. 41.

16. *Witness*, December 25, 1858.

17. See, for example, *Photographic News*, September 24, 1858, p. 29.

18. *Photographic Journal* [*Liverpool and Manchester Photographic Journal*], January 1, 1859, p. 7.

19. *Edinburgh News*, December 11, 1858.

20. *Photographic Journal* (note 18), p. 8.

21. *Photographic Notes* (note 2), p. 24.

22. *Witness* (note 16).

23. *Edinburgh Evening Courant*, January 11, 1859.

24. *Witness* (note 16).

25. *Edinburgh Evening Courant* (note 3).

26. F. Bachmann, *Die Landschaften des Aert van der Neer* (Neustadt-an-der-Aisch, 1966), pl. 4.

27. *Photographic Journal* (note 5), p. 23.

28. A. Maurois, *Victor Hugo*, trans. G. Hopkins (London, 1956), p. 338.

29. Ibid., p. 339.

30. This critic used the initials *P.M.F.* on publishing "Close Photographic Societies: The Press Excluded," *Photographic Journal* [*Journal of the Photographic Society of London*], February 15, 1859, p. 51.

31. By 1860, says Sara F. Stevenson, in *Thomas Annan, 1829–1887* (Edinburgh, 1990), p. 10. The idea that Annan acquired new equipment is based on the change in format of his photographs in 1860, not on documentary information (S. Stevenson to the author, January 10, 1990). Figure 5, *Dunkeld*, is attributed to Annan because of its likeness to related landscape prints known to be his that were sold at Sotheby's, London, on April 25, 1986 (lots 116–20). *Dunkeld*, part of lot 105 in the same sale, comes from the same album as these prints. The attribution is supported by Sotheby's photography expert Philippe Garner.

32. As is clear in the firm's advertisement in

Photographic News, September 10, 1858.

33. Unpub. holographic memoir of Robert Murray by his son, Robert C. Murray, quoted by kind permission of George Carter, Norwich, England.

34. George Carter collection, Norwich, England. The firm showed work by Claude-Marie Ferrier, Francis Frith, Charles Soulier, A. Clouzard, Roger Fenton, Philip Henry Delamotte, and others.

35. *Art-Journal* 5 (January 1859), p. 24.

36. The *Art-Journal* is listed in the contents of Townshend's library as part of the inventory taken at his death in 1868; see Registered Papers, Victoria and Albert Museum, London. See also "The Dawning of an Age, Chauncy Hare Townshend: Eyewitness," in M. Haworth-Booth, ed., *The Golden Age of British Photography, 1839–1900* (London, Philadelphia, and New York, 1984), pp. 11–21; M. Haworth-Booth, "A Connoisseur of Photography in the 1850s: Chauncy Hare Townshend," in P. Walch and T. Barrow, eds., *Perspectives on Photography: Essays in Honor of Beaumont Newhall* (Albuquerque, 1986), pp. 9–31.

37. *Art-Journal* 5 (February 1859), pp. 45–46.

38. A. Blackmore, "Photographs by Henry Bedford-Lemere," *History of Photography* 13, no. 4 (October–December 1989), pp. 369–71, links the print dealer Henry Hering to photographs of the "Clerkenwell Explosion" owned by Townshend.

39. To be found in Giroux's *Cottage at La Mère (Allier)* (circa 1855; London, Victoria and Albert Museum).

40. *The Pre-Raphaelites*, exh. cat. (Tate Gallery, London, 1984), pp. 101–2.

41. *Ford Madox Brown*, exh. cat. (Walker Art Gallery, Liverpool, 1964), pp. 20–21.

42. "Salon de 1859," *Oeuvres complètes* (Paris, 1976), vol. 2, p. 661.

43. March 1, 1854, p. 61.

44. *Morning Advertiser*, January 10, 1859, p. 3.

45. *Photographic Journal* (note 5), p. 23.

46. Ibid.

47. Another possible explanation is that Silvy's photograph faded—as did many exhibits.

48. *Athenaeum*, January 15, 1859, pp. 86–87.

49. *Photographic Journal* (note 5).

50. The chapter "Les Primitifs de photographie" in Nadar's *Quand j'étais photographe* (Paris, 1900) discusses his contemporaries and the 1855 exhibition. *Quand j'étais photographe* was reissued in J.-F. Bory, ed., *Nadar* (Paris, 1979).

51. See, for two examples out of many, the paper negatives by Edouard Baldus for the Mission Héliographique (from 1851), which were often heavily retouched in ink, especially foliage and water details (information from F. Heilbrun, Paris), and the calotype negatives datable to 1852–54 and later by Benjamin Brecknell Turner in the Royal Photographic Society, Bath, which clearly show Turner's work on foliage areas in pencil and on skies in india ink.

52. See "Pour ou contre le retouche (1855)," which reprints the arguments of Perier and Durieu, in A. Rouillé, *La Photographie en France, Textes et controverses: Une Anthologie, 1816–1871* (Paris, 1989), pp. 272–78.

53. *Photographic Journal* [*Journal of the Photographic Society of London*], September 16, 1861, p. 268.

54. The notes on Aguado are drawn from the entries on him in two catalogues by Bernard Marbot: *Une Invention du XIXe siècle: Expression et technique: La Photographie: Collection de la Société Française de Photographie* (Paris, 1976), and *After Daguerre: Masterworks of French Photography (1848–1900)*, exh. cat. (Metropolitan Museum of Art, New York, 1981). See also A. Jammes and E. Parry Janis, *The Art of French Calotype* (Princeton, 1983), pp. 137–38.

55. See the Aguado album, ref. no. A.10100, in the Bibliothèque Nationale, Paris, and such prints as *Troyes, le pont des blanchisseuses*, which shows houses and gardens by a river plus a

moving boat.

56. J. Borcoman, *Charles Nègre, 1820–80,* exh. cat. (National Gallery of Canada, Ottawa, 1976), p. 16. See also M. Gasser, "Between 'From Today Painting Is Dead' and 'How the Sun Became a Painter': A Close Look at Reactions to Photography in Paris, 1839–1853," *Image* 33, nos. 3–4 (1991), pp. 8–29.

57. *Bulletin de la Société Française de Photographie* 7 (June 1861), pp. 165ff.

58. Ibid., 4 (April 1858), p. 85.

59. Ibid., 4 (May 1858), p. 153.

60. Ibid., 4 (November 1858), p. 283.

61. Ibid., 5 (January 1859), p. 1. There is no record in the archives of the S.F.P. of when the print was received into the collection.

62. P. Greenhalgh, *Ephemeral Vistas: The Expositions Universelles, Great Exhibitions and World's Fairs, 1851–1934* (Manchester, 1988), p. 153.

63. *Bulletin de la Société Française de Photographie* 5 (August 1859), p. 153.

64. *Photographic Journal* [*Journal of the Photographic Society of London*], June 15, 1859, p. 153.

65. Ibid.

66. *Revue photographique* 4 (1859), p. 198.

67. The prints of *River Scene, France* known at present are discussed below. Prints of *Etude de moutons* are in the S.F.P. and Victoria and Albert Museum, London; *Etang de Gaillard* is in the Château Saint-Jean, Nogent-le-Rotrou; *Le Pressoir* and *Le Gué à La Croix-du-Perche,* possibly *Cour de ferme* (if this is identical with an untitled photograph of a young woman leading a cow), and a *carte de visite* portrait that appears to represent the king of Sardinia are all in the Monnier family collection, Paris.

68. *Photographic News,* May 6, 1859, p. 102.

69. Ibid., July 9, 1859, p. 1: "Ce sont de ravissants tableaux qui ont le mérite d'être vrais comme la nature elle-même, tout en empruntant à l'art ces prestiges qui poetisent les sites les plus vulgaires."

70. *Revue des beaux-arts* 2 (1859), pp. 258–61.

71. J.-A. Castagnary, "Salon de 1859," in *Salons, 1857–1870* (Paris, 1892), p. 86. See also A. Dumas, *L'Art et les artists contemporaines* (Paris, 1859), p. 89. The critical background is explained in H. van der Tuin, *Les Vieux Peintres des Pays-Bas et la critique artistique en France de la première moitié du XIXe siècle* (Paris, 1948).

72. L. Figuier, *La Photographie au Salon de 1859* (Paris, 1859), p. 9. Figuier's book is a collection of his review articles originally published in *La Presse.*

73. The Monnier family has very kindly provided a copy of Camille Silvy's birth certificate, which is now in the archives of the Photographs Section, Collection of Prints, Drawings and Paintings, Victoria and Albert Museum, London.

74. Nadar (note 50), p. 233.

75. P. Silvy to the author, August and November 1990. There are apparently fanciful details of the family history in C. Drigon, *Registre du livre d'or de la noblesse de la France* (Paris, 1844–52). An eleven-page typescript of the family history (hereafter Family History) compiled by Alexandre Monnier has been preserved by the Monnier family. A copy is in the archives of the Photographs Section, Collection of Prints, Drawings and Paintings, Victoria and Albert Museum, London.

76. A copy of the marriage document, dated September 10, 1827, is in the archives of the Photographs Section, Collection of Prints, Drawings and Paintings, Victoria and Albert Museum, London.

77. See *Les Maires de Nogent, 1790–1870* (Nogent, n.d.).

78. The historical background derives from P. Bruyant, *Nogent-le-Rotrou et ses environs* (Nogent-le-Rotrou, 1904).

79. These details appear in Hector (Count) Souancé, *Nogent-le-Rotrou* (Nogent-le-Rotrou,

1916).

80. G. Daupeley, "Jean-René Meliand, élève de Louis David, 1782–1831," *Nouvelles archives de l'art français*, 3d ser., 2 (1886), pp. 362–65.

81. See E. Lefèvre, *Dictionnaire géographique du département Eure-et-Loir* (Chartres, 1856).

82. *La Patrie*, quoted in *Le Nogentais*, February 19, 1854.

83. C. Silvy, *Album de la Garde Mobile d'Eure-et-Loir comprenant le récit de la campagne de 1870–71 par SILVY, vice-consul de France à Exeter, ex-lieutenant de la 7e compagnie du 4e bataillon. Première partie: Epernon. Seconde partie: Chartres* (Chartres, 1872). This account is augmented by details from the brief curriculum vitae set down by Silvy sometime after 1871 (Paris, Monnier family).

84. See J. Cuisenier, S. Lossignol, and D. Delouche, *Un Carnet de croquis et son devenir, F. H. Lalaisse et la Bretagne* (Brest, 1985). Mme Delouche has traced no reference to Silvy during the course of her research on Lalaisse (letter to the author, November 1990).

85. Silvy graduated *bachelier es-droit*, which means he studied law for two years. If he studied in Paris, it must have been at the Université de Droit de Paris. Normally at that time, the course of study lasted three years (to graduate *licensié de droit*). Silvy abandoned his law studies before their completion (F. Bardonnet, Paris, to the author, August 1991).

86. No details of Silvy photographs from Algeria appear, however, in the *Répertoire des collections de photographies en France* published by Documentation Française, Paris, in 1990.

87. De Ruminé's photograph *Pouzzoles, ruines de l'ancien marché dit temple de Serapis* is reproduced in F. Heilbrun, B. Marbot, and P. Néagu, *L'Invention d'un regard (1839–1918)*, exh. cat. (Réunion des Musées Nationaux, Paris, 1989), p. 202.

88. J. Szarkowski, *Photography until Now*, exh. cat. (Museum of Modern Art, New York, 1990), p. 71.

89. Ibid.

90. P. Burty, "Exposition de la Société Française de Photographie," *Gazette des beaux-arts* 2 (1859), p. 217.

91. R. Davray-Piekolek to the author, October 1990.

92. R. Davray-Piekolek to the author, April 1991.

93. Jean-Baptiste-Louis Moullin taught drawing at the Collège Saint-Laurent, Nogent-le-Rotrou, leaving in 1853 to become an illustrator for *Le Monde illustré* and *L'Illustration*.

94. "Voigtlander's Orthoscopic Lens," *Photographic Art-Journal* 1 (1858), p. 45. The commission (Bayard, Bertsch, and Foucault) presented their report in the *Bulletin de la Société Française de Photographie* 4 (March 1858), p. 67. Dr. Rudolf Kingslake has pointed out (letter to the author, November 1990) that there are two Orthoscopic lenses in George Eastman House, Rochester, with focal lengths of about 440 and 330 millimeters, respectively.

95. Kate Rouse's report gives this further analysis:

> The Petzval design was available at the time from two separate manufacturers—Dietzler and Voigtlander. However, in mid-1858, only one of Voigtlander's series would have had the angle of coverage for Silvy's large plate. The design had a maximum aperture of $f/8.7$ (see R. Kingslake, *A History of the Photographic Lens*, New York 1989) and was capable of taking a landscape in good light in as little as three seconds exposure as contemporary accounts show. It was what would now be termed a telephoto design, as it had a negative combination situated behind a positive one. It had a circle of illumination of a diameter of four-fifths the focal length. Thus it could only be used with plates with a diagonal smaller than the focal length of the lens and so it was slightly long focus. This raises the question as to whether the picture could have been taken with such a lens, as it looks deceptively "wide angle". However, it should be noted, in a modern attempt to repro-

duce Silvy's photograph from the same viewpoint by Stephen Shore in July 1990 [fig. 49] it was found that a standard lens gave the most appropriate angle of view, and so the Petzval lens cannot be ruled out. There is insufficient evidence to determine the presence of the "pincushion" distortion which afflicted this design, unlike many of the other lenses of the day.

96. *Photographic Notes*, March 1, 1860, p. 68.

97. "Epreuves photographiques avec ciels," *La Lumière*, August 7, 1852, p. 130.

98. "Skies and Clouds for Landscape Photographs," *Photographic Times*, April 15, 1863, p. 53.

99. V. Blanchard, "On the Production and Use of Cloud Negatives," *Photographic Times*, September 15, 1863, p. 138.

100. Lacan (note 97).

101. It was very kind of Mr. Adams to take the trouble to analyze the construction of Silvy's photograph when he was convalescing after a major operation.

102. J. M. Reilly, *The Albumen and Salted Paper Book: The History and Practice of Photographic Printing, 1840–95* (Rochester, N.Y., 1980), pp. 76–77.

103. Ibid. See also the valuable note "John Muir Wood and Photographic Chemistry" by Michael Gray, in S. Stevenson et al., *The Photography of John Muir Wood: An Accomplished Amateur 1805–1892* (Edinburgh and Berlin, 1988).

104. Jammes and Janis (note 54), p. 183.

105. G. Le Gray, *Plain Directions for Obtaining Photographic Pictures (&c)* (London, 1851), p. 20. Silvy refers with approval to Le Gray's treatises in *Photographic Journal* [*Journal of the Photographic Society of London*], September 16, 1861, p. 268.

106. *Photographic Journal* (note 53).

107. S.F.P., Paris.

108. Niepce de Saint-Victor's methods are summarized in *Photographic News*, April 21, 1859, p. 79.

109. W. Naef to the author, November 1990.

110. R. Hunt, *A Manual of Photography*, 4th rev. ed. (London and Glasgow, 1854), pp. 56–57.

111. W. Naef to the author, November 1990.

112. *Daily Scotsman*, December 17, 1859.

113. The title *Moulin* appears in the scrapbook referred to below, p. 68.

114. "Correspondence: Shading the Skies of Positives," *Photographic Notes*, May 15, 1859, p. 135. The treatment of skies in early photography was the subject of Bernard Marbot's exhibition and catalogue *Quand passent les nuages* (Bibliothèque Nationale, Paris, 1988), which included the S.F.P. print of *River Scene, France*.

115. See *Boeufs attelés* (1857) and photographs of dogs and pheasants by Aguado in the S.F.P., Paris. Aguado showed a group of these in the S.F.P. exhibition of 1857.

116. A reproduction of this photograph by F. Joubert's "Phototype" process (an ink process like collotype) was published with the June issue of the *Photographic Journal* in 1860. See B. Coe and M. Haworth-Booth, *A Guide to Early Photographic Processes* (London, 1983), pp. 84–85. No prints or correspondence appear to survive in the Goupil archive now at the Musée des Beaux-Arts, Bordeaux (P. Lin Renie to the author, December 1990).

117. *Album de la Garde Mobile d'Eure-et-Loir . . .* (note 83).

118. Ibid.

119. "Chroniqueuse" [Olive Logan], *Photographs of Paris Life* (London, 1861), p. 2.

120. Ibid., pp. 55–56, letter dated July 6, 1859.

121. The daybooks of Silvy's studio cover the period between August 1859 and July 1868, although one volume is missing. They are preserved in the National Portrait Gallery, London.

122. E. A. McCauley, *A. E. E. Disderi and the Carte de Visite Portrait Photograph* (New Haven and London, 1985), p. 1.

123. E. J. Hobsbawm, *The Age of Capital, 1848–1875* (London, 1975), chap. 2, sect. 2.

124. D. Lee, "The Victorian Studio: I," *British Journal of Photography*, February 7, 1986, p. 154.

125. A. Wynter, "Cartes de Visite," *Once a Week*, January 25, 1862, p. 137.

126. *Décors de l'imaginaire: Papiers peints panoramiques, 1790–1865*, exh. cat. (Musée des Arts Décoratifs, Paris, 1990).

127. The daybooks suggest that Silvy's artist was named Viersseaux.

128. The date of the Patti portrait is July 1861.

129. P. Garner, "Silvy Portrait—Arrested Motion," *History of Photography* 2 (January 1978), opp. p. 1.

130. These appear in two albums of royal portraits from the Sirot collection now in the Cabinet des Estampes, Bibliothèque Nationale, Paris.

131. In English in the original. Nadar's text was translated for this book by François Bardonnet.

132. Ibid.

133. Ibid.

134. Ibid.

135. Ibid.

136. Ibid.

137. Ibid.

138. Probably the publication listed in the British Library catalogue of printed books as *The Photographic Quarterly Review*, which was printed in Jersey (suggesting the participation of Thomas Sutton) and published in London. Two numbers appeared. The British Library copies are currently mislaid.

139. London street musicians are one of "les industries eccentriques" of England discussed in *La Revue des deux mondes* 20 (1859), pp. 105–53.

140. R. Krauss, "Tracing Nadar," *October* 5 (Summer 1978), pp. 29–47.

141. *"Louis Maria {Sforza} called the Moor, Duke of Milan. Manuscrit Sforza. Fac-simile d'après le manuscrit original appartenant à M. le marquis d'Azeglio, ambassadeur de Sardaigne à Londres.* Photographie et publié par C. Silvy, Librairie Photographique, 38 Porchester Terrace, Bayswater, W London 1860." The volume includes Silvy's "Reproduction et restauration des manuscrits anciens par la photographie."

142. Silvy's letter appeared in *Photographic Journal* [*Journal of the Photographic Society of London*], July 15, 1861, p. 226, and—in answer to the controversy it aroused (ibid., August 15, 1861, pp. 241–44)—was followed by a longer letter addressed to Antoine Claudet by Silvy (ibid., September 16, 1861, pp. 267–71). The remarks by E. Fierlants were published in *La Revue photographique* 8 (1862), p. 258.

143. Silvy's panoramic camera investigations appeared in *Bulletin de la Société Française de Photographie* 13 (1867), pp. 37, 172–73. The camera body he designed is in the National Museum of Science and Industry, London. For the device for keeping the lens horizontal to the ground, see *Le Moniteur de la photographie* (1863), p. 178.

144. On Silvy and photoceramics, see *Le Moniteur de la photographie* (1866), p. 192; on the Dreux chapel photographs, see *Bulletin de la Société Française de Photographie* 11 (1865), pp. 288–89.

145. *British Journal of Photography*, October 6, 1871, p. 476.

146. *Photographic Times*, February 1, 1863, pp. 14–15.

147. Philippe Garner has established that Silvy's business partner in London was Jean Renoult. The partnership was dissolved in 1864 (letter to the author, July 1990). This is presumably the same Jean Renoult who is credited with photographs illustrated in Count Souancé's history of Nogent-le-Rotrou (note 79).

148. C. Silvy, *A messieurs du conseil municipale de la ville de Nogent-le-Rotrou* (London [published by Silvy at 38 Porchester Terrace], 1867). A copy is in the Bibliothèque Nationale, Paris.

149. Lee (note 124), p. 155, has shown that Silvy's studio sittings reached a high point of 806 in a single month (May 1861). There were 762 for

the 12-month period between July 1867 and July 1868.

150. Adolphe Beau's reminiscence of photography in the 1860s is published in F. Whyte, *Actors of the Century* (London, 1898), pp. 189–93. A paragraph about Silvy is reprinted, unsourced, in the entry on him in C. Beaton and G. Buckland, *The Magic Image* (London, 1975).

151. May 5, 1862, no. 9334.

152. H. W. (W. H.?) Wills sat to Silvy on April 9, 1861.

153. *All the Year Round*, April 26, 1862, p. 167.

154. Portraits that include *River Scene, France* as a visible accessory include nos. 8097–8108, 10096–99, 10102–3, 10279–80, 10366, 10369, 10371, 10455, 10478–79, 10502, 10506, 10508, 10512, 10686–90, 10693, 12939–40, 15758. Other photographs, presumably by Silvy himself, appear in nos. 7749, 10712, 10716, 13412, 15888. (This is not an exhaustive list.)

155. *L'Annuaire diplomatique* lists Silvy as "agent consulaire de France à Exeter et Tynemouth," 1869–80. The post was not part of the regular diplomatic service of France, in that no examinations were required, and was mainly honorific. There may be further information in the *Personnel—Agences consulaires* files in the French Embassy in London, but these are yet to be located by the embassy archive.

156. Silvy (note 83).

157. Family History (note 75) quotes *Le Gaulois* for July 21, 1877, on Silvy's war bravery and states that he was wounded "under the walls" of Paris fighting against the Commune.

158. Silvy (note 83). The copy in the Bibliothèque Nationale contains a handwritten note in the back of the second part addressed to "M . le Prefet" by the printer Durand and dated May 30, 1900. Durand states that only two of the projected five parts were published. The last three were not even written, "l'auteur étant tombé malade." A note written on the cover of the first pamphlet states that the photographs, plates, and lithographs listed in the table of contents were not included because they had not been printed, nor were they likely to be. This note is dated April 4, 1893.

159. *Photographic Journal* [*Journal of the Photographic Society of London*], February 15, 1860, p. 158.

160. J. Sagne, *L'Atelier du photographe 1840–1940* (Paris, 1984), p. 239.

161. *Le Moniteur de la photographie* 141 (1874), pp. 106, 146.

162. *La Petite France* (Tours), May 26, 1885.

163. *Le Moniteur de la photographie* (note 161), p. 151.

164. Ibid.

165. *La Petite France* (note 162): "Par arret de la Cour d'appel d'Angers du 5 janvier 1881, on le declara interdit."

166. The death certificate, which describes Silvy as "ancien avoué," states his address as no. 57 Grand Rue, Saint-Maurice, Canton de Charenton.

167. His grave is located in the third division, second section, third line.

168. H. Schwarz, *Art and Photography: Forerunners and Influences* (Rochester, N.Y., 1985), p. 107.

169. Quoted in M. Haworth-Booth, "Benjamin Brecknell Turner: Photographic Views of Nature," in *British Photography in the 19th Century: The Fine Art Tradition*, ed. M. Weaver (New York, 1989), p. 81. The question of mirrors and doubling is explored by Craig Owens in "Photography *en abyme*," *October* 5 (Summer 1978), pp. 73–88.

170. E. Parry Janis, "Photographie," in *L'Art en France sous le Second Empire*, exh. cat. (Grand Palais, Paris, 1979), p. 466.

171. K. Varnedoe, "The Artifice of Candor: Impressionism and Photography Reconsidered," *Art in America* 68, no. 1 (January 1980), pp. 71–72.

172. *Le Nogentais*, August 8, 1858; August

14, 1859.

173. M. Silvy to the author, November 1990.

174. T. J. Clark, *The Painting of Modern Life: Paris in the Art of Manet and His Followers* (London, 1985), p. 184.

175. Ibid., p. 168.

176. M. Rothlisberger and D. Cecchi, *L'opera completa di Claude Lorrain* (Milan, 1975), pl. 38, *Landscape with Shepherds* (Paris, Musée du Louvre inv. 320), pp. 88–89.

177. Townshend's picture, recorded in his collection in 1857, has been on loan from the South Kensington Museum/Victoria and Albert Museum since 1896. See N. Maclaren, *National Gallery Catalogue: The Dutch School* (London, 1960), p. 378.

178. The evolution of the genre and its subtle variations are analysed by W. Stechow in *Dutch Landscape Painting of the Seventeenth Century* (London, 1966), pp. 50–65.

179. See the interdisciplinary magazine *Landscape Research* (Cherry Burton, North Humberside, England), e.g., D. R. Helliwell, "Perception and Preference in Landscape Appreciation—A Review of the Literature," no. 12 (1976), pp. 4–6.

180. J. Appleton, *The Experience of Landscape* (London, 1975), p. 59. See also idem, *The Symbolism of Habitat: An Interpretation of Landscape in the Arts* (Seattle, 1991).

181. On progressive farming methods in Le Perche, see Dureau de la Malle, *Description du Bocage Percheron, des moeurs et coutumes des habitans, et de l'agriculture de M. de Beaujeu* (Paris, 1823).

182. My warm thanks to John Szarkowski, Director, Department of Photography, Museum of Modern Art, New York, 1962–91.

183. My thanks to Bob Press, Natural History Museum, London, and Nick Turland.

184. G. Flaubert, *Madame Bovary: A Story of Provincial Life*, trans. A. Russell (Harmondsworth, 1950), p. 93.

185. P. Hayes Tucker, *Monet in the '90s: The Series Paintings*, exh. cat. (Royal Academy of Arts, London, 1990), pp. 148–51.

186. Quoted in D. Mrazkova, *What is Photography? 150 Years of Photography* (Prague, 1990), p. 54.

187. C. Ginzburg, "Clues and Scientific Method," *History Workshop Journal* (1980), pp. 5–36.

188. M. Haworth-Booth, "Dickens, les detectives et la photographie," in P. Bonhomme, ed., *Les Multiples Inventions de la photographie* (Paris, 1989), pp. 143–48.

189. Clark (note 174), pp. 164–69.

190. John House refers to Seurat's aim, in *La Grande Jatte*, of making "the moderns file past like the figures on the Pan-Athenaic Frieze of Phidias" (*Postimpressionism*, exh. cat. [Royal Academy of Arts, London, 1979], p. 133).

191. Clark (note 174), p. 204.

192. Julian Barnes applied the term *plein-air* to the 1960s films of Truffaut and Godard in "Night for Day," *New York Review of Books*, October 11, 1990, p. 14. I have reapplied it to an earlier *plein-airiste*.

193. This and the following quotations are from J. L. Godard, *Pierrot le fou* (London, 1984), pp. 51–52.

194. A group of Shore's photographs from Nogent-le-Rotrou is in the collection of the Getty Museum.

195. C. Milosz, *The Collected Poems (1931–1987)* (London, 1988), p. 221.

SELECTED BIBLIOGRAPHY

In addition to material cited in the text and notes, the following titles—and the further references they contain—may be found useful.

Baldwin, G. *Looking at Photographs*. Malibu and London, 1991.

Bierman, J. *Napoleon III and His Carnival Empire*. London, 1990.

Braudel, F. *The Identity of France*. Vol. 1: *History and Environment*. Trans. S. Reynolds. London, 1989.

Bretell, R., et al. *A Day in the Country*. Exh. cat. Los Angeles County Museum of Art, 1984.

Brogan, D. W. *The French Nation from Napoleon to Petain, 1814–1940*. London, 1989.

Champa, K. S. *Studies in Early Impressionism*. New Haven and London, 1973.

Galassi, P. *Before Photography*. New York, 1981.

Greenough, S., et al. *On the Art of Fixing a Shadow: One Hundred and Fifty Years of Photography*. Exh. cat. Washington, D.C.: National Gallery of Art, and Art Institute of Chicago, 1989.

Heilbrun, F., B. Marbot, and P. Néagu. *L'Invention d'un regard*. Exh. cat. Paris: Réunion des Musées Nationaux, 1989.

Janis, E. Parry. *The Photography of Gustave Le Gray*. Exh. cat. Art Institute of Chicago, 1987.

Naef, W., and B. Marbot. *After Daguerre: Masterworks of French Photography (1848–1900) from the Bibliothèque Nationale*. Trans. M. S. Eigsti. Exh. cat. New York: Metropolitan Museum of Art, 1980.

Nochlin, L. *Realism*. Harmondsworth, 1971.

Parsons, C., and M. Ward. *Bibliography of Salon Criticism in Second Empire Paris*. Cambridge, 1986.

Perrot, M. *A History of Private Life*. Vol 4: *From the Fires of Revolution to the Great War*. Cambridge, Mass., and London, 1990.

Pollock, Sir M. *Light and Water: A Study of Reflexion and Colour in River, Lake and Sea*. London, 1903.

Scharf, A. *Art and Photography*. Harmondsworth, 1974.

Zeldin, T. *France, 1848–1945*. 4 vols. Oxford, 1980.

ACKNOWLEDGMENTS

I first saw Camille Silvy's photograph at the Victoria and Albert Museum, London, in *"From Today Painting Is Dead": The Beginnings of Photography* (1972), an exhibition organized by Dr. David Thomas of the Science Museum, London, and Joanna Drew of the Arts Council of Great Britain. My friend the late Richard Hough, founding director of Stills Gallery, asked me to write about Silvy's photograph at the time of his Edinburgh Festival exhibition, *Mid 19th Century French Photography: Images on Paper*, in 1979. Christine Frisinghelli and Manfred Willman invited me to Graz, Austria, to speak about the photograph in 1982 and published my talk in *Camera Austria* (nos. 11–12 [1983]). I began to wonder if—because I habitually find myself working outward from the very specific—writing a book-length study of one photograph might be a productive way for me to think about the medium. I was therefore delighted when the present publication was proposed by the J. Paul Getty Museum in 1989. I should like to record my gratitude to Christopher Hudson, Head of Publications, and Weston J. Naef, Curator of Photographs.

I was able to work on this project while at the University of Sussex as part of an academic exchange in 1989–90. I warmly thank Elizabeth Esteve-Coll, Director, and John Murdoch, Assistant Director, Victoria and Albert Museum, and Professor Marcia Pointon, University of Sussex, for making this wonderful year possible. Apart from the pleasures of working with university staff and students, I owe them a debt for helping me to open out my research in many different directions. In addition, two scholars have been vitally important to this study: Dr. John House, Courtauld Institute of Art, University of London, and Philippe Garner, photography expert at Sotheby's, London, and a long-time student and devotee of Silvy. Both have been unsparingly generous.

Many friends and colleagues, and complete strangers, have responded kindly to my sometimes desperate interrogations over the years. I should like to thank all of them most sincerely. In addition to those I have already mentioned in the course of my

text and notes, I have particular debts to the following: Virginia Adams and the Ansel Adams Publishing Rights Trust, for permission to quote extracts from the letter from Ansel Adams; the staff of the Department of Photographs, Getty Museum, especially Gordon Baldwin; Catherine Cheval, Roger-Viollet photographic agency, Paris; Barbara Gray and Michael Gray, Curator, Fox Talbot Museum, Lacock Abbey, who taught me—somewhere between Bath and Lacock—how to focus a fifteen-by-seventeen-inch camera on reflections; Françoise Heilbrun and Philippe Néagu, Musée d'Orsay, Paris, for their expert help on puzzling details of the Parisian 1850s; Madeleine Ginsburg, formerly Department of Textiles and Dress at the V&A, for very helpful discussions on costume; Bridget Henisch and Professor Heinz Henisch, Editor, *History of Photography*, 1977–90; Dr. Mike Weaver, Editor, and Anne Kelsey Hammond, Associate Editor, *History of Photography*, since 1991; the late Arthur Gill; André Jammes, Paris; Julie Lawson and Sara Stevenson, Scottish National Portrait Gallery; Gérard Lévy and François Lepage, Galerie Gérard Lévy, Paris; Françoise Lecuyer-Champagne, Château Saint-Jean, Nogent-le-Rotrou; Jean-Claude Lemagny and Bernard Marbot, Bibliothèque Nationale, Paris; Terence Pepper, National Portrait Gallery, London; Marina Warner, London, for her illuminating remarks about the photograph; all of my unfailingly helpful and stimulating colleagues in the Collection of Prints, Drawings and Paintings at the V&A—Susan Lambert, Curator; Lionel Lambourne; Sarah Postgate; Ronald Parkinson; Lucy Davenport; and especially Chris Titterington, Assistant Curator of Photographs, who has made many fertile observations and suggestions; and my colleagues in the Conservation Department at the V&A, including Graham Martin; Boris Pretzel; and especially Elizabeth Martin, Senior Conservator of Photographs. I am also grateful to the staff of the Science Museum Library and the National Art Library at the V&A, especially David Wright, and to Pamela Roberts, Royal Photographic Society, Bath; Mme Christiane Roger, Société Française de Photographie, Paris; Adrian Budge and Roger Taylor, National Museum of Photography, Film and Television, Bradford; and John Ward, National Museum for Science and Industry, London. My research in Paris has been supported in every possible way by a long-standing friend and colleague, Danielle Demetz-Heude, Inspection Générale des Musées Classés et Contrôlés, Direction des Musées de France, Paris, and her husband, Yves Heude. It

was with them that I found myself standing—in July 1990—in the farmyard in which Camille Silvy made some of his earliest photographs. François Bardonnet, at that time a student at the Ecole du Louvre (and attached to the Collection of Prints, Drawings and Paintings at the V&A in 1990), helped me to solve research and translation problems in London and Paris; Carolyn Peter, student attachment from the Courtauld Institute of Art in 1990–91, was also invaluable. I have had the pleasure and great benefit—to my sense of Silvy himself and of the culture to which he belonged—of conversations with his descendant Françoise Monnier-Dominjon, Paris. The architect Maurice Silvy pursued many questions of detail on my behalf in Nogent-le-Rotrou and Paris; his imaginative understanding of his forebear's artistry has been of the greatest help. I thank most cordially the Monnier family, descendants of Camille Silvy; their help has effectively transformed our understanding of his life and work.

At some phases during my writing and research, two remarks came to keep me company. On a good day, I thought of "Generalization is the enemy of man" (Milosz). On a less good day, I remembered "I hear a German professor has published a book on lemon peel" (Rousseau). However, it has been a joy to work with my editor, Andrea P.A. Belloli.

Apart from Silvy's wonderful picture, and the help of many friends, Rosie, Emily, and Alice inspired this book—which is dedicated to them with love.

The Getty Museum Studies
on Art seek to introduce
individual works of note or
small groups of closely related
works to a broad public with
an interest in the history of art
and related disciplines. Each
monograph features a close
discussion of its subject as well
as a detailed analysis of the
broader context in which the
work was created, considering
relevant historical, cultural,
chronological, and other
questions. These volumes are
also intended to give readers
a sense of the range of
approaches which can be taken
in analyzing works of art
having a variety of functions
and coming from a wide range
of periods and cultures.

Christopher Hudson, Head of Publications
Andrea P. A. Belloli, Series Editor
Patricia Inglis, Series Designer
Eileen Delson, Designer
Amy Armstrong, Production Coordinator
Ellen Rosenbery, Photographer

Typography by Wilsted & Taylor, Oakland
Printed by South China Printing Co. Ltd., Hong Kong

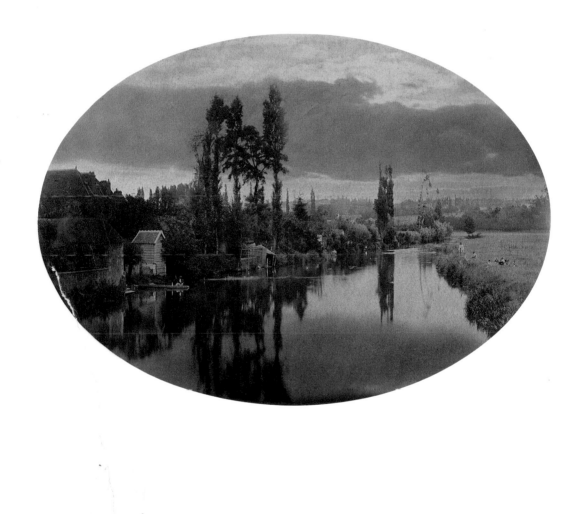